LIFE LIBRARY OF PHOTOGRAPHY

The Art of Photography
Revised Edition

BY THE EDITORS OF TIME-LIFE BOOKS

TIME-LIFE BOOKS, ALEXANDRIA, VIRGINIA

Revised Edition. First printing.
Published simultaneously in Canada.
School and library distribution by Silver Burdett
Company, Morristown, New Jersey 07960.

For information about any
Time-Life book, please write:
Reader Information, Time-Life Books,
541 North Fairbanks Court,
Chicago, Illinois 60611.

TIME-LIFE is a trademark of
Time Incorporated U.S.A.

Library of Congress Cataloguing in Publication Data
Main entry under title:
The Art of photography.
 (Life library of photography)
 Bibliography: p.
 Includes index.
 1. Photography, Artistic. I. Time-Life
Books. II. Series.
TR642.A76 1981 779 81-14433
ISBN 0-8094-4172-1 AACR2
ISBN 0-8094-4170-5 (retail ed.)
ISBN 0-8094-4171-3 (lib. bdg.)

ON THE COVER: Looking through
the lens of a camera and visualizing in
his mind's eye a picture (also
reproduced on page 135), the
photographer himself— not his
equipment— is the most important
element in the art of photography. His
unique vision of the world, his
experiences and memories, as much as
his skills, are his real creative tools. With
them he selects and organizes the raw
materials before him, creating a
photograph to which others can respond.

Contents

Time-Life Books Inc.
is a wholly owned subsidiary of
TIME INCORPORATED

FOUNDER: Henry R. Luce 1898-1967

Editor-in-Chief: Henry Anatole Grunwald
President: J. Richard Munro
Chairman of the Board: Ralph P. Davidson
Executive Vice President: Clifford J. Grum
Chairman, Executive Committee: James R. Shepley
Editorial Director: Ralph Graves
Group Vice President, Books: Joan D. Manley
Vice Chairman: Arthur Temple

TIME-LIFE BOOKS INC.
MANAGING EDITOR: Jerry Korn
Executive Editor: David Maness
Assistant Managing Editors: Dale M. Brown
(planning), George Constable, Martin Mann,
John Paul Porter, Gerry Schremp (acting)
Art Director: Tom Suzuki
Chief of Research: David L. Harrison
Director of Photography: Robert G. Mason
Assistant Art Director: Arnold C. Holeywell
Assistant Chief of Research: Carolyn L. Sackett
Assistant Director of Photography: Dolores A. Littles

CHAIRMAN: John D. McSweeney
President: Carl G. Jaeger
Executive Vice Presidents: John Steven Maxwell,
David J. Walsh
Vice Presidents: George Artandi (comptroller);
Stephen L. Bair (legal counsel); Peter G. Barnes;
Nicholas Benton (public relations); John L. Canova;
Beatrice T. Dobie (personnel); Carol Flaumenhaft
(consumer affairs); James L. Mercer (Europe/South
Pacific); Herbert Sorkin (production); Paul R. Stewart
(marketing)

LIFE LIBRARY OF PHOTOGRAPHY
EDITORIAL STAFF FOR
THE ORIGINAL EDITION OF
THE ART OF PHOTOGRAPHY:
EDITOR: Richard L. Williams
Picture Editor: Carole Kismaric
Text Editor: Jay Brennan
Designers: Sheldon Cotler, Raymond Ripper
Assistant Designer: Herbert H. Quarmby
Staff Writers: John von Hartz, Bryce S. Walker
Chief Researcher: Peggy Bushong
Researchers: Sondra Albert, Frances Gardner,
Kathryn Ritchell
Art Assistants: Patricia Byrne, Lee Wilfert

EDITORIAL STAFF FOR
THE REVISED EDITION OF
THE ART OF PHOTOGRAPHY:
EDITOR: Edward Brash
Designer/Picture Editor: Sally Collins
Chief Researcher: Jo Thomson
Text Editor: John Manners
Researchers: Rhawn Anderson, Diane Brimijoin,
Elise Ritter Gibson, Charlotte Marine
Assistant Designer: Kenneth E. Hancock
Art Assistant: Carol Pommer
Editorial Assistant: Jane H. Cody

Special Contributors:
John Neary, Gene Thornton (text)

EDITORIAL PRODUCTION
Production Editor: Feliciano Madrid
Operations Manager: Gennaro C. Esposito,
Gordon E. Buck (assistant)
Quality Control: Robert L. Young (director),
James J. Cox (assistant), Daniel J. McSweeney,
Michael G. Wight (associates)
Art Coordinator: Anne B. Landry
Copy Staff: Susan B. Galloway (chief), Ricki Tarlow,
Celia Beattie
Picture Department: Eric Godwin
Traffic: Kimberly K. Lewis

CORRESPONDENTS:
Elisabeth Kraemer (Bonn); Margot Hapgood, Dorothy
Bacon, Lesley Coleman (London); Susan Jonas, Lucy
T. Voulgaris (New York); Maria Vincenza Aloisi,
Josephine du Brusle (Paris); Ann Natanson (Rome).
Valuable assistance was also provided by:
Judy Aspinall (London); Carolyn T. Chubet, Miriam
Hsia, Christina Lieberman (New York); Mimi
Murphy (Rome).

The editors are indebted to the following individuals
of Time Inc.: George Karas, Chief, Time-Life Photo
Lab, New York City; Herbert Orth, Deputy Chief,
Time-Life Photo Lab, New York City; Melvin L. Scott,
Assistant Picture Editor, Life, New York City; Photo
Equipment Supervisor, Albert Schneider; Time-Life
Photo Lab Color Technicians, Peter Christopoulos,
Luke Conlon, Henry Ehlbeck, Robert Hall.

There is no question that photography is a popular hobby, a craft, a trade for many, a profession for some, a tool of science and very likely a science in itself. Whether it is also an art used to be a question, but that argument is over. The use of a camera does not disqualify a photographer from being taken seriously as an artist, any more than the use of a typewriter disqualifies a poet, playwright or novelist.

Neither does the camera or typewriter, however expensive, make the artist; they are conveniences. Sophisticated equipment, as Carl Mydans once said, simply "frees us from the tyranny of technique and enables us to turn to what photogra-phy is all about—creating a picture."

That is also what this book is about: creativity and esthetics, not metering and f-stops. The vocabulary of esthetics is different from the vocabulary of technology, and both take getting used to, but one is no more mysterious than the other. In this volume there is a good deal of material, both visual and verbal, that seeks to explain how some of the fundamental principles of esthetics apply to photography. The principles are not confining but liberating; they allow for many individual approaches to art, from the dutifully conventional to the convention-defying.

One unusual picturemaking technique, which appears in this revised edition for the first time, abandons the conventional camera altogether and employs the office copy machine, with magical results *(pages 166-172)*. The principles apply to its products as well as to pictures made with ordinary cameras. To be sure, simply learning the principles and seeing how they operate will not assure you a place among great artists, but, by showing you why good pictures are good, the information will free you to make better pictures of your own. As Carl Mydans also put it, "one is not really a photographer until preoccupation with learning has been outgrown and the camera in his hands is an extension of himself. There is where creativity begins."

The Editors

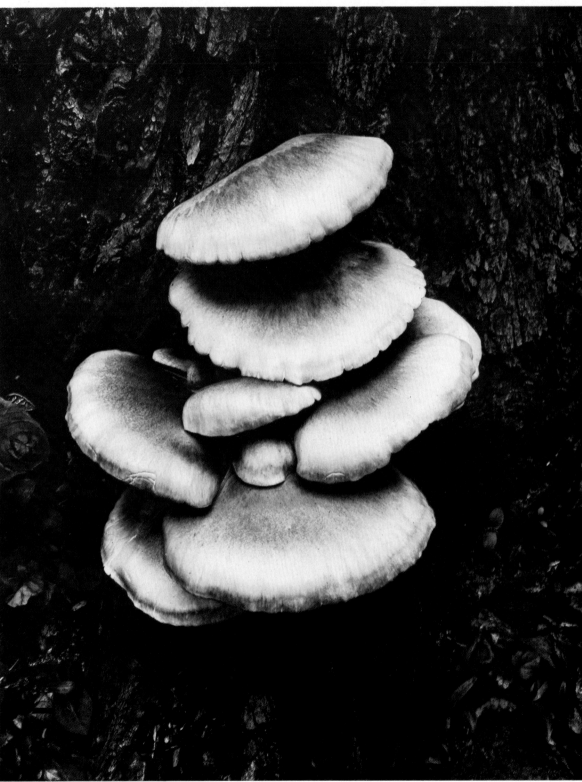

RALPH WEISS: *Oyster Mushrooms,* 1969

The Making of a Fine Photograph

Scenario 1: A businessman is half a continent from home, walking through a city with a camera in his hand. His appointments for the day are over. Rather than sit in his hotel room and read until dinnertime, he has decided to devote the rest of the afternoon to his new hobby — photography. On this crisp afternoon, the city is even more photogenic than he had expected. Sunlight is sparking off cars and buildings, and a gentle wind is riffling flags and coats.

Strolling toward the heart of the business district, he keeps his eyes alert for promising subjects. Many sights tempt him: a cluster of street signs mounted on a single pole; a newspaper vendor with narrowed, cynical eyes; a moving van debouching desks and chairs; a helicopter clattering over the roofs of the city. But each of these subjects seems too limited.

His attention is arrested by one huge new office building. Gleaming and stark, it looks more like a machine than a place where human beings spend their days. At the ground level is a long, empty arcade, bordered on one side by black marble columns and on the other by a glass-walled lobby. The building strongly appeals to him. But how should he photograph it? He could aim his camera upward or he could shoot down the long arcade. Either of these approaches would express the great scale of the office building, but he is after something more original and meaningful.

Suddenly he spies a possible solution. Inside the glass-enclosed lobby are small potted trees. Several people are sitting on a bench nearby, but it is the trees that interest him. Surrounded by the stern, rectilinear strength of the building, they seem very frail. There is something both touching and a bit ridiculous about them. Why, he wonders, do architects construct cold edifices of glass, steel and concrete, then feel compelled to import a bit of nature into their shining technological world? He suspects that these potted trees are going to help him make an extraordinary picture.

His first impulse is to go inside the lobby and take the photograph from there. Then he decides that the trees would look much more interesting if seen from outside the glass walls. An exterior vantage point would give a clear indication of their setting, which is crucial to the point he wants to get across. A picture that displays the building as well as the trees will communicate the irony of outdoor organisms surviving in an air-conditioned, hermetically sealed environment in which nighttime and daytime arrive at the flick of a switch.

Having decided to shoot from the outside in, he must now cope with the problem of reflections in the glass walls of the lobby. These mirrored images, if picked up by his camera, are likely to obscure the view of the trees on the other side of the glass; they could be eliminated with a special polarizing filter, but he does not have one with him. Just as he is beginning to taste disappointment, an answer presents itself. All he has to do is make sure that

> ANSEL ADAMS: *I have often thought that if photography were difficult in the true sense of the term — meaning that the creation of a simple photograph would entail as much time and effort as the production of a good watercolor or etching — there would be a vast improvement in total output. The sheer ease with which we can produce a superficial image often leads to creative disaster. We must remember that a photograph can hold just as much as we put into it, and no one has ever approached the full possibilities of the medium.*

the glass is reflecting some dark, featureless object. This kind of reflection will be virtually invisible, and the camera will be able to peer through the glass at the trees. Happily, just such a dark background is readily available to him: He will stand in a position where the glass walls reflect one of the huge black marble columns.

When he steps between one column and the glass and raises the viewfinder to his eye, he sees that his picture will include a view of the arcade. Stretching into the distance, it gives a sense of the building's size. He also notices that at this angle the column does not block all the reflections from across the street. The viewfinder shows that the reflection of an office building will appear in the right-hand portion of the picture. But the more reflections the merrier, he thinks, as long as the potted trees are still visible. The added images will make the picture more interesting. Satisfied, he adjusts the focus and exposure and shoots the picture, certain that it will be one of the best he has ever taken. He is mistaken.

When he sees the print *(page 14)* several days later, he cannot help wincing. The result is not at all what he had in mind. The picture seems muddled and pointless. For one thing, the trees — prime objects of his attention — are barely visible through the glass. In the shadowed lobby, they have practically no dramatic impact; they are upstaged by the more brightly lit arcade and the reflections of the outdoors. And these reflections are confusing. Cars and trucks that he failed to see when he looked through the viewfinder appear to be driving right through the lobby. There is a reflection of another tree — outdoors — that blunts his point about the irony of importing nature into the alien world of a modern building. This outdoor tree is leafless, setting up distracting questions about the season and the requirements for growth.

The list of defects seems endless. He wonders why he tripped the shutter just when the woman in the lobby turned her head away. He wonders why he did not notice the dim reflection of another building at the far right-hand side of the picture, or why he did not spot the reflection of the strange sack lying at the foot of the marble column. How could he have chosen a horizontal format for the picture, instead of a vertical one more suited to skyscraper verticality? The failure of his picture is obvious. Instead of according it honor in his collection, he throws it in the wastebasket.

Scenario 2: Late in the afternoon a second photographer wanders by. He, too, observes the potted trees and is intrigued for many of the same reasons as the first photographer. By now the sun is lower in the sky, and a shaft of light is streaming into the lobby, setting the leaves ablaze. However, the tops of the trees are still in shadow. He decides to postpone photographing the scene until the sun has descended a few more degrees, fully illuminating the

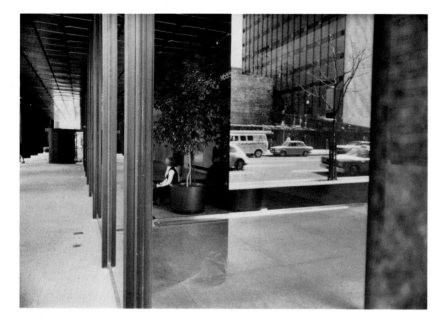

The amateur who took this picture hoped to suggest the irony of decorating the glass-walled lobby of a skyscraper with potted trees — but ended up with a confused array of visual elements that is almost impossible to interpret.

trees. He does not want to waste film on a shot that he knows he will be dissatisfied with later and so he continues his walk.

Half an hour later he returns and finds that the illumination is just right. The shaft of sunshine is a powerful spotlight piercing the dimness of the lobby and singling out the trees. A woman is now sitting near the trees, as if their living greenery were offering her comfort in this cold, modern skyscraper.

Before he even begins to consider how the picture should be composed, he tries to clarify his feelings about the scene. Like the first photographer, he is struck by the incongruity of nature in a glass-and-steel office building. It occurs to him that the conflict is not just between this building and these trees, but between any modern urban architecture and any trees. There is some essential opposition to be communicated here, something that transcends the specific ingredients of this scene and makes a broad statement about cities and nature.

How can he communicate his sense of transcendent meaning? Standing at the same spot where the first photographer stood, he considers every element that might appear in the picture. He knows that he will have to stay at this position between the glass wall and the black marble column, so that the dark reflection of the column will enable the camera to see the trees beyond the glass. This necessary location narrows his options, but there are still a number of pictorial ingredients to be handled: the reflections of cars, a leaf-

*Given the same subject matter, British photographer
Tony Ray-Jones selected some of the available
visual elements, discarded others and transformed
still others to produce the picture at right — a strong
comment on the relationship of nature and cities.*

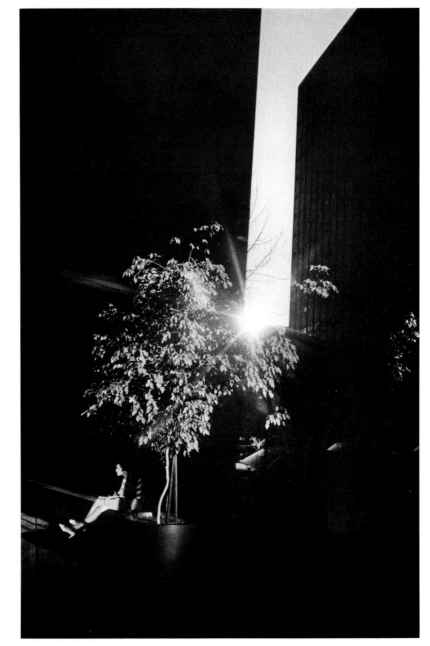

less tree and an office building across the street; the long view of the arcade; the reflection of the column; and the glass wall itself.

Shall he include all these ingredients or pare away some? The arcade conveys the look of modern urban architecture, but seems wrong for his purpose. It leads the eye away from the trees, which are central characters in the picture he wants to make. But if he does not show the arcade, how can he express the flavor of urban architecture? The answer comes at once: The reflection of the office building across the street will communicate the look of the cityscape. He does not need the arcade at all. By eliminating it, he gains, because the specific location of these trees is now obscured. They could be anywhere, in any city — a valuable ambiguity because it broadens the meaning of his picture.

Assessing the other reflections, he decides that the leafless, outdoor tree should be eliminated too. It strikes him as confusing and inappropriate. He is concerned with a conflict between living plants and inanimate buildings. The thrust of his theme would be blunted by a leafless tree suggesting some state of half-death. He decides to skip that tree and the arcade.

The reflected cars, on the other hand, are pertinent to his statement about natural versus man-made things, and he decides to include them in the picture. Finally there is the reflection of the black column itself. It would be possible to reveal the column for what it is by aiming the camera slightly downward to show the base reflected in the glass. But identifying the column would serve no purpose, and he decides not to. However, while he can conceal the column's reality, he cannot eliminate its reflection, for this dark image allows the trees behind the glass to be visible. Then he notices a resemblance between the vertical edge of the column reflection and the shape of the building across the street.

Musing on this similarity of shape, a bold idea comes to him. If the interior of the lobby (except for the trees and woman) is pitch black in the picture, the straight edge of the column reflection might produce the illusion of a huge black skyscraper looming up behind the indoor trees. To pull off this illusion, he will have to position himself fairly close to the glass, excluding both the reflected base of the column and the roof of the arcade; only if these visual clues are missing will the viewer be unable to tell that dark, straight-edged shape from a skyscraper.

Now he realizes that if everything in the scene, except the trees and woman, is rendered in a very dark tone, the viewer will have no way of knowing that reflections make up crucial elements of the picture. The glass wall of the lobby will disappear. And this suits his purpose perfectly, because he wants trees and city to be in direct opposition, with nothing between them.

He steps toward the glass and peers through his viewfinder to see how this scheme will work. With a horizontal format it does not work at all; the strong

> *EDWARD WESTON: The photographer's most important and likewise most difficult task is not learning to manage his camera, or to develop, or to print. It is learning to see photographically —that is, learning to see his subject matter in terms of the capacities of his tools and processes, so that he can instantaneously translate the elements and values in a scene before him into the photograph he wants to make.*

vertical elements demand a vertical frame for the picture, and he turns his camera. Next, he moves around and tries different camera angles, seeking the best arrangement of the various parts in the scene. He tries centering the trees in the frame, but this placement seems to spoil the illusion of a looming black skyscraper behind the trees. He decides to put the trees in the bottom of the frame. This shift in camera angle yields an extra dividend: It allows the top of the building across the street to be seen, so that the viewer's attention will be held within the picture.

Correct exposure will make or break this photograph, and he plans to bracket with enough shots at different apertures and shutter settings to be sure that he will get great tonal range. The trees and woman must be very bright, as if they alone, in this cold urban world, were touched with the fire of life. Everything else must be dark, brooding and impossible to locate with any degree of sureness. His greatest asset, he realizes, is the brilliant sunlight on the trees. They will remain lightly visible even if he underexposes to make the reflections dark and the interior of the lobby pitch black.

All this time, the photographer has been assuming that he will shoot from a position where the column will cut off the mirror image of the sun in the glass wall, since strong rays reflected from the sun would produce flare, streaking the image with a star pattern of light. But now he steps a few inches to the right to see what might happen to his pictorial scheme if a bit of the reflected image of the sun were included. The effect is both interesting and disconcerting. Because he intends to obscure the fact that reflections are present in the picture, the sun will appear to be behind the trees. Yet this apparent position will be impossible to reconcile with the way that light is falling on the trees — from the front.

At once, he realizes that this "impossibility" is the ingredient that will make the picture complete. The mystery of the scene will be deepened by the paradox of light that seems to be coming from two directions at once. It will build conflict into the frame — a shiver of illogic to heighten the clash between nature and the city. And yet, because the sun's image will be located near the center of the picture, it will be a force for visual stability — a bright central point around which everything else is organized.

At last he is ready to shoot. Since the exposure is tricky and he is not sure how much flare will be caused by the rays of the sun, he takes a number of pictures, moving his position slightly so that greater and lesser amounts of mirrored sunlight reach the camera, and bracketing his exposures at each position. This effort is a gamble, and the photographer wants to give himself every chance for success.

His diligence pays off. When he examines his prints, he finds one picture that more than lives up to his hopes *(page 15)*. It presents a dreamlike vision

pinioned on the spokes of a sunburst. In the midst of a brooding, gloomy cityscape, a little clump of trees offers its scrap of shade to a solitary woman. Here is a world of powerfully opposed tones, ghostly shapes, stray floating leaves and strange-looking lighting phenomena. And yet every ingredient that has been used is cemented into a compelling whole.

The difference between the two photographers need not be ascribed to intellect, sensitivity or any other vague requisite for success in photography. The first photographer was a man of imagination and intelligence. He had excellent equipment, good intentions and strong feelings about his subject matter. Yet he produced a picture that looks boring, confused and pointless.

His failure—and the second photographer's success—ultimately depended on one vital factor: intelligibility. The second picture is much clearer and more comprehensible than the first. The first picture is a babble of many meanings that drown one another out. The viewer is unsure what to respond to and can only guess at the photographer's intention. What went wrong?

The photographer started out with a good idea: to convey the incongruity of trees growing in a modern office building. But he indiscriminately piled all sorts of ingredients together and hoped that the camera would automatically extract the meaning he sensed was there. He did not forge visual or thematic links to connect one ingredient to another and unify them.

The photograph accords about the same amount of importance (or unimportance) to arcade, glass, lobby, woman, trees and reflections. The arcade was included because he realized that it made the building look big. The reflection of the office building across the street was included because he vaguely felt that it would make the picture more interesting. The reflections of the cars and the leafless tree were included because he never saw them in the first place—and he also missed the dim reflection of still another office building that showed up in the shiny marble of the column. In short, he never really figured out how to integrate all the elements of the scene, and the result is incoherence.

What was the secret of the second photographer's success? He did what his predecessor did not: He clarified his thoughts and feelings about the subject. He, too, was intrigued by the incongruity of trees in a modern office building. But instead of snapping a picture on the basis of this twinge of interest, he analyzed the meaning of the scene, and set out to trace its appeal to the source. He realized that *these* trees and *this* office building were not his real concern. At stake was a fundamental incompatibility between nature and urban architecture. And the more he looked at the scene, the more he detected a definite bias within himself. Cities, in his view, are grim and heartless, whereas nature is luminous and quick with life. Like the sunlit woman sitting near the trees, he cast his lot with nature.

> *AARON SISKIND: As the saying goes, we see in terms of our education. We look at the world and see what we have learned to believe is there. We have been conditioned to expect. And indeed it is socially useful that we agree on the function of objects. But, as photographers, we must learn to relax our beliefs. Move on objects with your eye straight on, to the left, around on the right. Watch them grow large as you approach, group and regroup as you shift your position. Relationships gradually emerge and sometimes assert themselves with finality. And that's your picture.*

The working method of the second photographer was a complex process of exploration and selection. He examined all of the objects before his camera — the building, its contents and its surroundings — and explored the meanings that might be attached to them. During this period of observation, many potential pictures beckoned — the trees, the arcade, the woman, the reflections. Then one idea — the paradox of life within a sterile skyscraper — seemed richer and more compelling than any other. Whatever was irrelevant or distracting he excluded. What remained was carefully positioned in his viewfinder so that its importance was evident. He tuned the mix of these elements, like a musician seeking a chord whose notes blend perfectly. And when he was sure that every part would fit together and contribute to the whole, he took the picture.

This analytical approach is not unique to photography, but it is applicable. Photography is a special art in that the exploration and selection must be done either in advance of picture taking, before the shutter is tripped, or afterward in the darkroom. It is as though a composer were to conceive a symphony complete from beginning to end, push a button, and presto! An orchestra would play the music. The very ease with which film can generate an entire picture hinders many photographers from developing their skills. They may be misled into believing that all they have to do to guarantee at least one good picture is take a great number of shots of a subject, and they concentrate on the act of image-recording rather than on the process of picture creation. In many cases, a large number of shots are advisable, but quantity alone cannot assure success. It is the carefully thought-out photograph that communicates its maker's message.

In analyzing a picture, the skillful photographer performs three different sorts of exploration. He examines his feelings and thoughts about the subject — in short, its meaning to him. He examines all the visual attributes of the scene, seeking those that will best convey his sense of the meaning. And he considers various ways in which the chosen visual elements can be arranged in the picture, so that the meaning can be efficiently grasped. In practice, these three sorts of exploration go on simultaneously, each influencing the others. Noticing a particular shape might suggest a new meaning and the need for a certain design. The explorations may be quick or even intuitive; some photographers speak of instantaneous "recognition" of what to shoot and how to shoot it. Conversely, many fine photographers spend a great deal of time contemplating their subjects and adjusting the tiniest details.

Breaking up the creative process into three areas of exploration and selection is only the initial step, of course. Each area — meaning, visual characteristics, arrangement — is itself subject to additional exploration and selection. Meaning, for example, depends on the memories, cravings,

aversions, training and intelligence of the beholder. Most people looking at a certain round, red object will identify it as an apple. At this first level of meaning, they simply recognize the object for what is is. Looking closer, they ascertain its state of ripeness, and they relate the object to their memories of eating apples and their current degree of appetite. Emotions such as happiness, worry or disgust might come into play. And some people might grasp subtler meanings: the way the apple grew, the symbolism of the intricate shades of its red skin, the uses that an apple might be put to, and so on.

As this apple example demonstrates, the exploration of meaning is guided by the visual characteristics of the subject. These characteristics, in turn, can be explored in a very direct way because they are fundamentally objective. The roundness and smoothness of apples — or of mushrooms *(page 11)* or human bodies *(page 39)* — are facts, measurable ones if need be. Similar attributes are identifiable in every object, so that the appearance of a subject can be classified in an orderly manner *(pages 22-56)*.

The arrangement of objects within the picture is also subject to direct analysis, for every arrangement can be gauged according to widely accepted standards. We say that a picture seems balanced or unbalanced, for example, but balance is only one of the attributes influencing human perception; many others are discussed in Chapter 2.

These techniques of exploration confront the photographer with choice after choice. Should he emphasize the bright texture of leaves on the potted trees? Or the hard line of a reflection in the glass? Should the trees be centered in his frame or placed to one side? His choice seems to be intuitive: If he is pressed to rationalize, he is likely to say only, "It looks better this way." But intuition is shaped by experience — by lifelong exposure to the responses that are common to the human race. And it can be sharpened by studying photographs that are acknowledged to be successful. Not that the techniques and styles of great photographers should be copied. Rather they should be analyzed for the underlying principles that helped the pictures communicate meanings so effectively.

This emphasis on meaning is justified even though the photographer cannot be sure his viewers will share his own responses to his subject. A photographer who perceives an apple as delectable may depict that meaning of deliciousness with great success for most viewers. Yet a person who hates apples will have a different response when he looks at the picture. He will probably see the apple as an undesirable object, since his attitudes and emotions play as large a role in perception as his eyes. Nevertheless, if the photograph is successful, the apple-hating viewer will recognize its intended meaning — and he will appreciate its expressive power, if only because his negative response is so strong.

> *BERENICE ABBOTT: A photograph is or should be a significant document, a penetrating statement, which can be described in a very simple term — selectivity. To define selection, one may say that it should be focused on the kind of subject matter which hits you hard with its impact and excites your imagination to the extent that you are forced to take it. Pictures are wasted unless the motive power which impelled you to action is strong and stirring. The motives or points of view are bound to differ with each photographer, and herein lies the important difference which separates one approach from another. Selection of proper picture content comes from a fine union of trained eye and imaginative mind.*

Such personal differences are, in fact, the lifeblood of photography. The people who take pictures are as idiosyncratic in their response to a subject as are those who view pictures—perhaps more so, because good photographers try harder to strip away familiar, predictable meanings in order to reveal their personal ideas. Different photographers might have depicted the potted trees and the city in totally dissimilar ways. One might have expressed joy in the play of colors; another might have celebrated the achievements of human ingenuity by showing the trees as dull and earthbound amid sparkling, soaring architecture; still another might have suggested calm by presenting the trees and bench as an island of repose.

But if any interpretation is legitimate, what makes one picture a work of art and another one not? This question is a philosophical tar pit wherein may be found the fossils of many once-glorious theories. Plato said that art springs from a "divine madness" that seizes the artist. Aristotle, trying to keep his feet on the ground, described art as a means of inducing psychological reactions in the beholder. Other philosophers have tried to define a common denominator for all art in terms of "beauty," "ideal form," "spiritual harmony," "intensified reality" and other vague concepts that might drive a purely practical mind to despair.

Even though the essence of art may never be pinned down, there are some broad guidelines to creative photography. They stem from the analytical approach described above. The photographer must consider the meaning of his subject, its visual attributes, and various schemes for organizing its elements. There are no absolute laws of esthetics to bind him, aside from the one requirement that these three considerations contribute to an intelligible whole. If this requirement is fulfilled, the picture will do honor to its creator —and may even qualify as a work of art. □

The Visual Elements: Shape

The art of photography, being a visual art, depends on the act of seeing raised to a high level of acuteness and discrimination. Ordinarily, people skim-read the everyday world with their eyes and minds, using only a minimum of clues to identify and assess what they see. A certain shape instantly denotes a pair of pliers; a certain glittery surface indicates ice; a red light means "stop." In daily life, there usually is no time to linger over such seemingly non-essential matters as the color of the pliers, the reflections in the ice or the dimensions of the traffic light. As long as the viewer does not mistake the pliers for a hammer, slip on the ice or have an automobile accident, his perceptual faculties have done their job.

A good photographer must train himself to do a more penetrating kind of seeing, to catch the meaning of a subject (that is, its meaning to him). Since this meaning may be extremely subtle and complex, he often must postpone any conclusions about it until all of the visual evidence is in. While there are innumerable ways of organizing that evidence, in the case of most seeing there are four traditionally useful approaches to visual information. In the terminology of the artist, they are defined as: shape, that is, the two-dimensional outline of an object; texture, its surface characteristics; form, its three-dimensional aspect; and color. The photographer considers all four.

Photographer Sebastian Milito has demonstrated this in the exercise on the opposite and following pages, systematically exploring the various visual characteristics of a single object.

Of the four elements, shape is the logical starting point because it is, for the photographer's purpose, the simplest component, suggesting only vertical and horizontal dimensions.

Not only are shapes different, but various lenses can make still other differences. A wide-angle lens, if aimed from a low angle, will turn a tall building into a pyramid; a long lens, by diminishing the effects of converging lines, may produce an image whose shape conforms more closely to mental expectations of the same building. By forgetting about its "normal" appearance altogether, the photographer may be able to find many nonrepresentational shapes in a scene. This is because anything that appears in a photograph —whether it is a fishing rod, an apple or a human being—not only produces a shape on the two-dimensional surface of the picture, but also acts as a boundary, creating shapes on either side of it.

How should the photographer use shape? He can shoot at an unexpected angle to make the viewer look twice at the subject (a pair of pliers, seen nose-on, may be a tantalizing mystery). He can create several shapes that echo one another, linking parts of a complex scene into a whole. He can display his subject as a construction of diverse geometric figures. If he knows how to see shape as an independent component, every scene will offer innumerable creative options. Yet he will have just begun to tap the visual riches of the world, for at least three other visual ingredients remain to be explored.

These photographs show four strikingly different views of the same object. The photographer chose to present the object as a riddle, hiding its identity for a time so as to present the various versions of its shape without being bound by preconceptions as to how it "should" look. Each of the pictures actually shows two shapes, of course—one dark, one light—a further dividend derived from an analytical approach to vision.

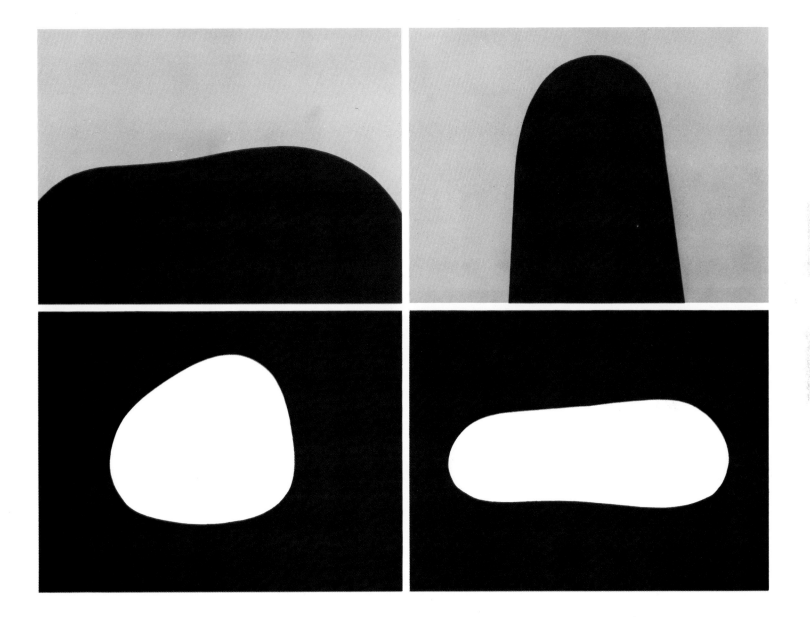

Revealing Texture

Once he has defined a subject's shape, a photographer—much like an explorer who has merely sailed around the coasts of a new continent—may next consider what lies within that shape, what textural details it holds. To allow the surface of an object to remain terra incognita sounds inconceivable, and yet day-by-day human perception often does exactly that. For texture usually becomes crucial only when something must be held, walked on, slept on, eaten—in short, whenever it must be touched.

The textures of billboards, rain gutters or suspension bridges are not of pressing concern, so they usually go unnoticed, although they may be very interesting if one bothers to notice them. But photography cannot afford such oversights if all its possibilities of perception are to be realized.

Even though photographic images are flat, they can evoke texture, which is by its nature three dimensional, with remarkable success. Modern lenses and film can capture the finest details of a surface, and a variety of lighting techniques can exploit, or even simulate, any sort of textural quality—jagged, glossy or anything in between.

For the picture at right of the same object whose shape was explored on the preceding page, the photographer has employed sidelighting to rake across its surface, emphasizing its pitted texture. He could have chosen to use other methods, either increasing the magnification to achieve an extremely craggy effect, or using frontlighting to make the surface look like polished metal. As is the case with shape, the discovery of texture as a distinct visual aspect of every object presents a greatly enhanced range of creative opportunities.

The same still-unidentified object whose shape was explored on the previous pages is now studied for its texture. A light placed off to one side throws shadows on the surface, showing its irregularly pitted character. The photographer has as yet presented no clue to the object's distance or size; and this sort of texture could belong to anything from a moonscape to an orange peel.

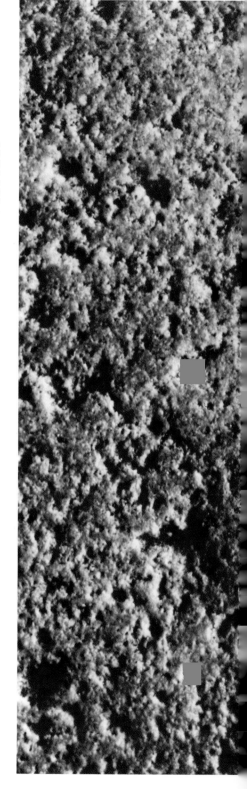

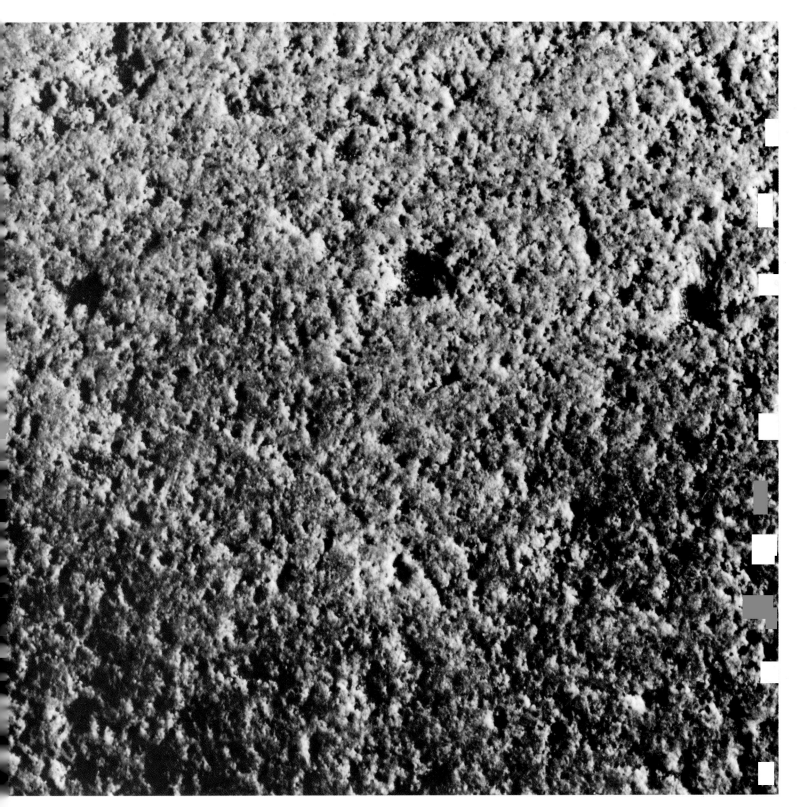

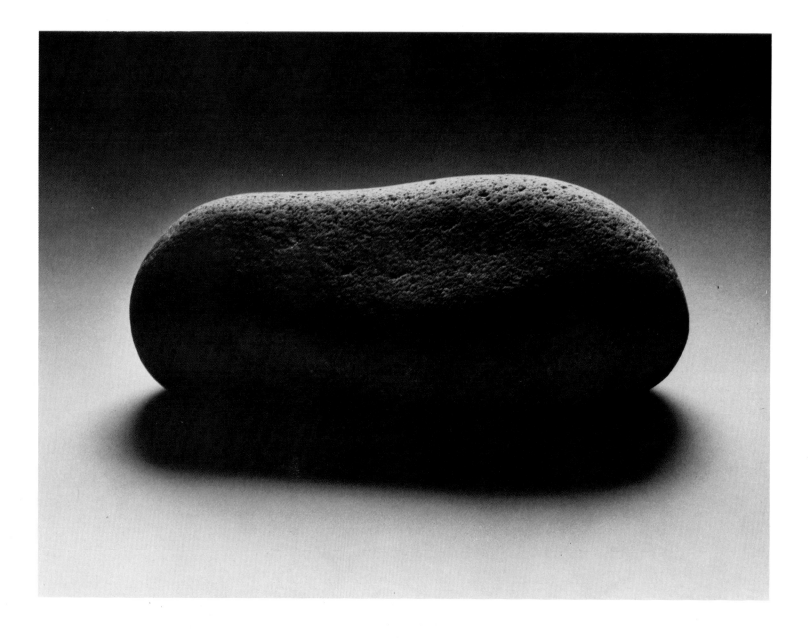

In art, form is distinguished from shape as the three-dimensional aspect of an object—it describes the way the object occupies space. Like texture, which also implies a third dimension, form might seem to be beyond the natural powers of photography. A camera, being one-eyed and not binocular, cannot perceive depth as well as human vision can. Happily, there are a number of two-dimensional clues to the third dimension: the manner in which shadows are cast, the effects of perspective, the overlapping of far objects by near ones. The photographer must be aware of such clues if he is to control the way his two-dimensional pictures transmit an impression of space and substance.

On these pages, only light and shadow have been employed to show the form of the object. Now, for the first time, the object's identity is clear: it is a rock, whose sculpted roundness is almost palpable. The two pictures not only reveal its form, or volume, but also give conflicting hints about the density of the object. The photograph opposite makes the rock ponderous; the lighter-toned version at right presents a rock that appears almost to float.

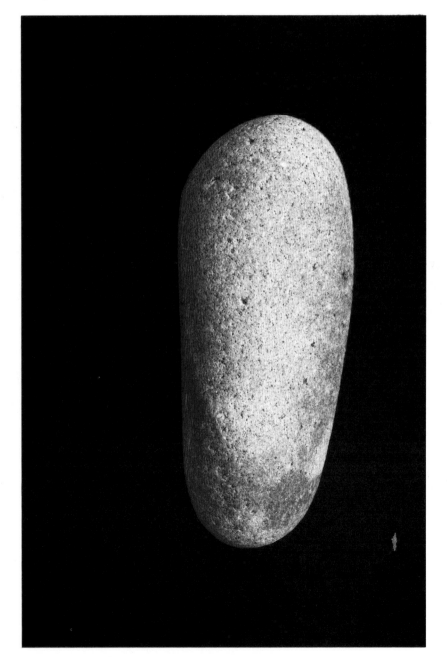

A gradual progression of tones (right), from dark to light, leaves no doubt as to the roundness of the rock, and even suggests the way it was formed—by centuries of slow, steady abrasion at the seashore. Much lighter than the background, the rock seems in this portrait an object that could easily be hefted, as if made of pumice.

◀ *Illuminated by an overhead light, the same rock displays few intermediate tones, and its volume is proclaimed emphatically. Here it looks weighty; predominantly dark, it seems to be sinking heavily into the soft-edged shadow at its base.*

27

Recording Color

Color might seem to be the most immediately evident of all the components of seeing: Who, except the blind and the color-blind, does not see the green of leaves, the red of valentines or the ever-changing tints of the ocean? But the fact is that colors are carelessly perceived a great deal of the time, because people generally see the colors that they expect to see. An object that is usually pink is only more or less pink—or not pink at all—under a tree, where it may assume a greenish cast; in the blue glow of a fluorescent light; or placed next to a yellow wall, where it picks up a reflection of the wall's color. A camera, which labors under no preconceptions, may record all such subtle color changes.

Take Milito's rock, for instance. It was picked up on an island off the coast of Rhode Island; most such rocks, worn by the glacial ice that deposited them and by millennia of friction, appear to be colorless at first glance—mostly white, or perhaps a little yellowish. But the textured close-up at left and the highlighted picture opposite reveal that the rock's visual assets include striking rust-red flecks and stains on its subtle beige background. It is not, then, to be regarded solely as an object of shape, texture and form; it exhibits another aspect of vision that is detectable by the seeing eye: color. □

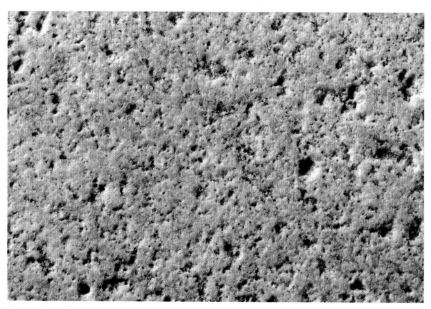

To see what a difference color can make in the perception of an object, compare the photograph above with the black-and-white close-up of the rock's texture on pages 24-25. In the picture opposite the color view brings out a richness of tone that sets this rock apart as a unique object.

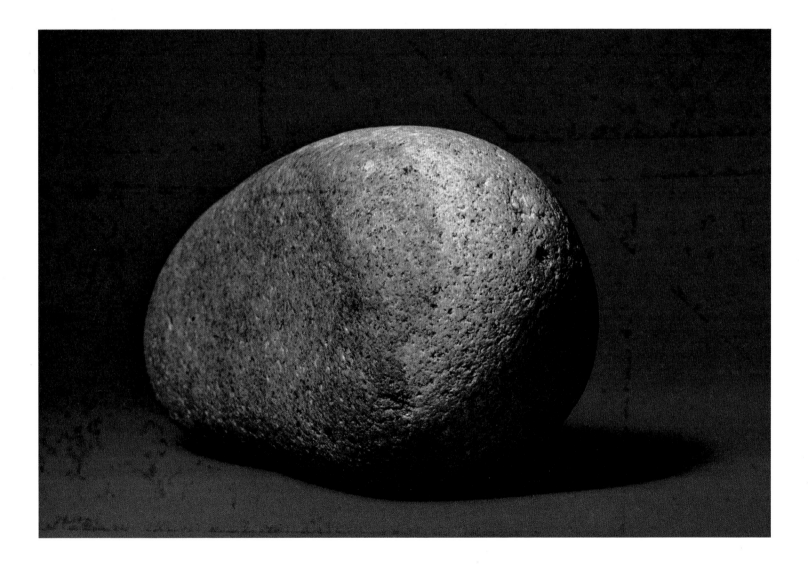

The Elements on Display: Shape

For the photographer, *seeing* shape, texture, form and color is only the first step. He must now suppress, emphasize or otherwise manipulate all these elements according to his own view of the object he is looking at. No law dictates that all of these approaches to seeing must be acknowledged in one picture—any more than all the instruments in an orchestra must play during every moment of a symphony. The photographer refines ordinary perception, disregarding all superfluous aspects of his subject matter—much like Michelangelo, who, it was once said, freed the form that lay within a block of marble.

The pipes in the photograph opposite offered a wide choice of temptations to Sebastian Milito: their shapes, their machined texture, their rounded forms, their blue-black color. He settled for shape, dispensing with everything else. "I saw the pipes," Milito says, "as gun barrels against the sky." A rendition of all four visual elements might have weakened the intended analogy by too explicitly identifying the ominous shapes and thus distracting the viewer's attention from the photographer's purpose.

The photographs on the following pages show how any one of these approaches to seeing can be the principal way of inferring a meaning from an object or producing a reaction to it. In each case, the choice seems almost obvious. Yet this only indicates how hard the photographer worked at seeing his subject; truly cogent selection of one visual mode depends upon careful consideration of them all—if only in order to reject all but one.

Silhouetted against the sky, circular rims just visible as they rise from a black mass, these pipes stacked on the Brooklyn waterfront bear a resemblance in shape to cannon arrayed for attack. A heavy red filter blocked the blue light from the sky, as well as the light bouncing off the blue-black surface of the metal, but it allowed the film to record the light reflecting off the clouds and the unpainted rims of the pipes.

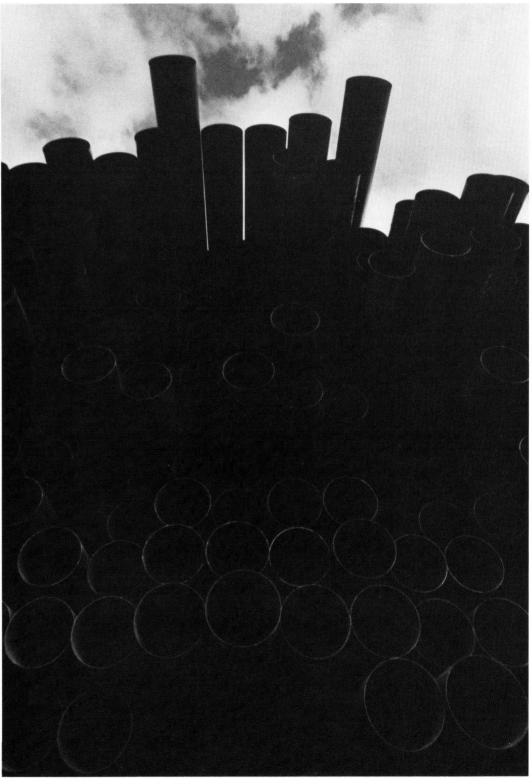

SEBASTIAN MILITO: *Pipes*, 1970

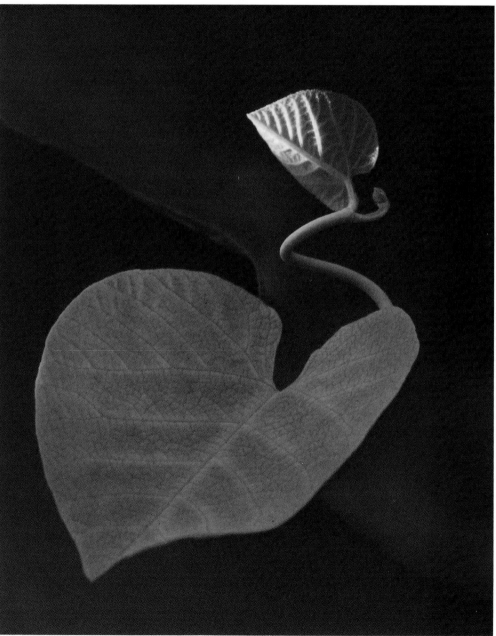

PAUL CAPONIGRO: *Two Leaves*, 1963

Soft natural light caresses the tilted-valentine shape of a Dutchman's-pipe leaf at left. The area within the leaf's sinuous boundaries, depicted in a subtle play of low-key tones, seems essentially flat, but the smaller, highlighted leaf and spiraling stem lend the suggestion of a third dimension.

The contours of a woman's nose are repeatedly ▶ amplified in the high-contrast photograph opposite, first by the similarly shaped crook of her arm, then by the outer edge of the arm, which extends beyond the picture frame. Using harsh lighting and printing for sharp contrast, the photographer excluded all but the face and arm, letting the eye and mouth help explain what otherwise would have remained a minor mystery.

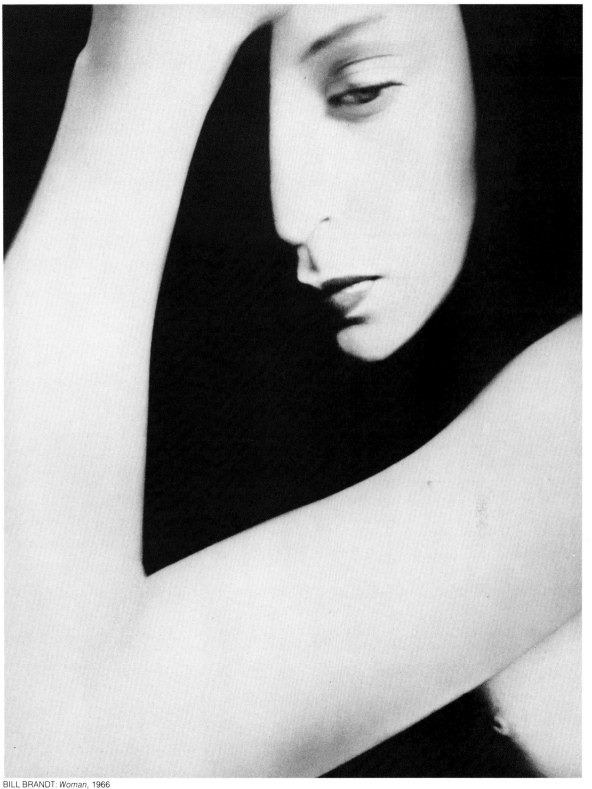

BILL BRANDT: *Woman*, 1966

Strong Patterns

In both the natural and man-made world, shapes often repeat themselves and produce a pattern—the windows of a sky-scraper, the leaves shown here in silhouette, or the stark hills on the opposite page. Pattern differs from texture, which also displays repetition, because pattern does not necessarily imply a third dimension, as texture does.

It is perhaps because pattern is a kind of order and our minds seek order in the world around us that the eye searches, consciously or not, for patterns in the surrounding scene. If a single shape has been multiplied many times, the pattern's regularity is immediately apparent. If the shapes are similar but not identical, like the shaded and sunlit slopes on the opposite page, the order may be less obvious—but the discerning photographer who detects the underlying unity can employ that fact to create pictures replete with subtle rhythms.

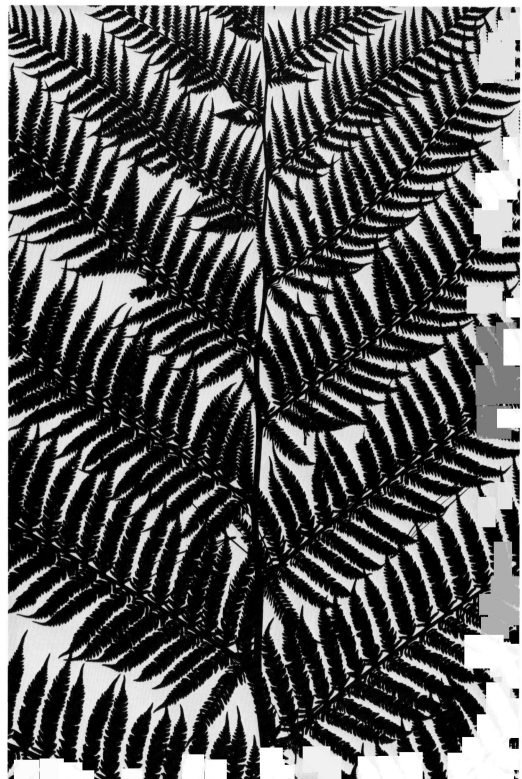

The strongly ordered pattern exhibited in this photograph of leaves was created in part by some darkroom manipulation. The negative was underexposed and overdeveloped to suppress detail and was then printed on contrasty paper. One slight deviation from symmetry enhances the pattern's organization: The stems are not perfectly opposed, but take turns, as it were, as they emerge from the branch.

GEORGE TICE: *Tree No. 19, California, 1965*

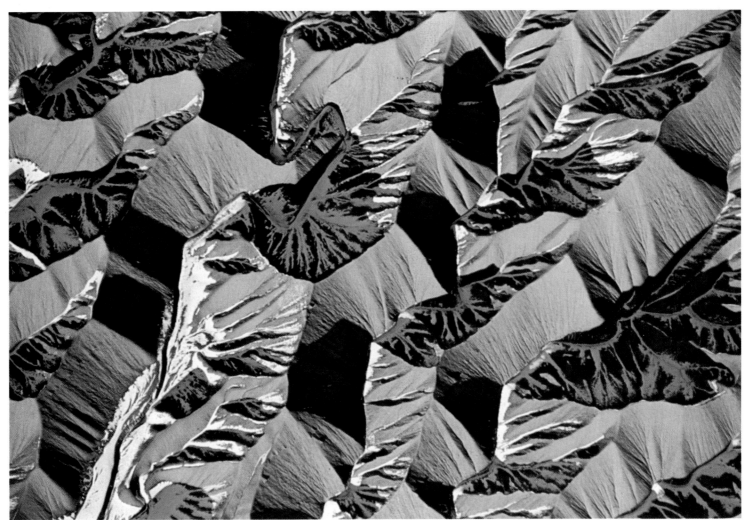

WILLIAM GARNETT: *Caineville, Utah*, 1967

*The early morning sun turns the snow-dusted slopes
of shale beds near Utah's Capitol Reef National
Park into a patterned frieze of gold and ivory. Color
not only reveals the repetition in the topography,
but adds the fascinating secondary patterns of
sun-gilded sand and snow.*

Sensual Textures

Revealing texture in a subject gives it a substance that takes it a dimension beyond bare shape or pattern. Light and shadow can create the impression of texture in black-and-white photographs, but texture emerges at its most sensuous only in color. Richly textured surfaces are loaded with fascinating eye-arresting detail, and when they are photographed with color film—especially slow color film in which details are enhanced by a fine-grain emulsion—every nuance of shade helps to convey the reality of the original.

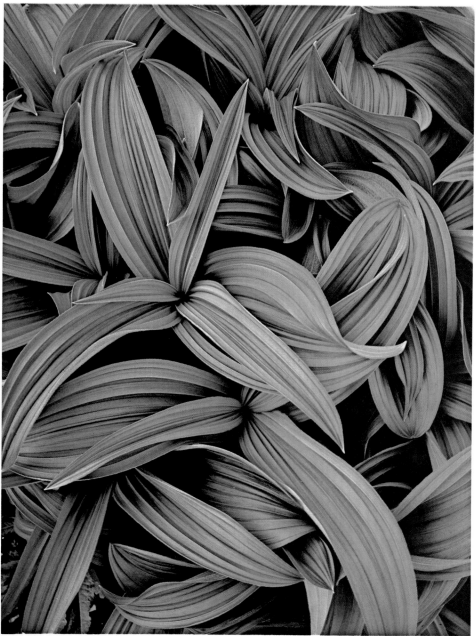

Color accentuates the cool, sleek surfaces of a swirl of hellebore leaves that covers the floor of a forest in the North Cascades of Washington state. The varied green tones also separate the plants from one another and from their background, revealing them as individually sculpted and striated botanical beauties.

STANLEY R. SMITH: *False Hellebore, 1975*

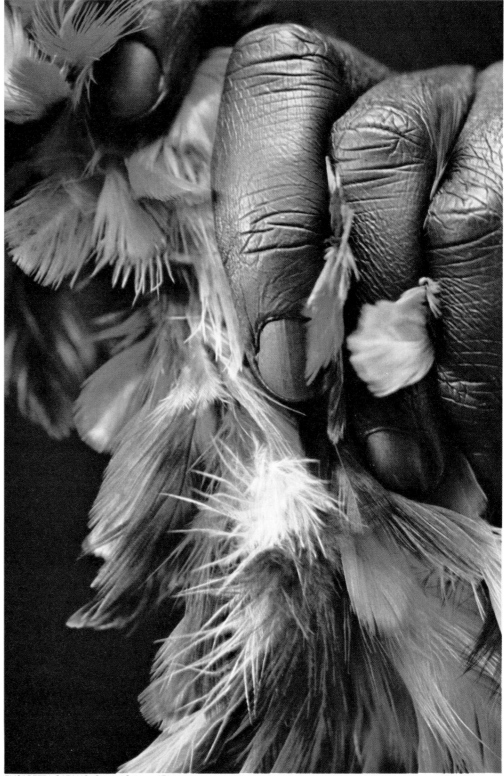

The flesh and fluff in this picture of a model's painted fingers clasping a gaudy bouquet of dyed feathers were arranged in a studio to illustrate contrasting textures. The photograph renders the objects almost palpable by showing them close up, framing them tightly and letting strong crosslight deepen every contour of their surfaces.

ELISABETTA CATAMO: *Captive Colors*, 1979

Vivid Forms

Framing his subject against the sky to emphasize its form, Aaron Siskind converts a pair of feet into an intricately balanced sculpture that might have been carved by wind or water. In making a picture, Siskind says, "I want it to be an altogether new object — complete and self-contained."

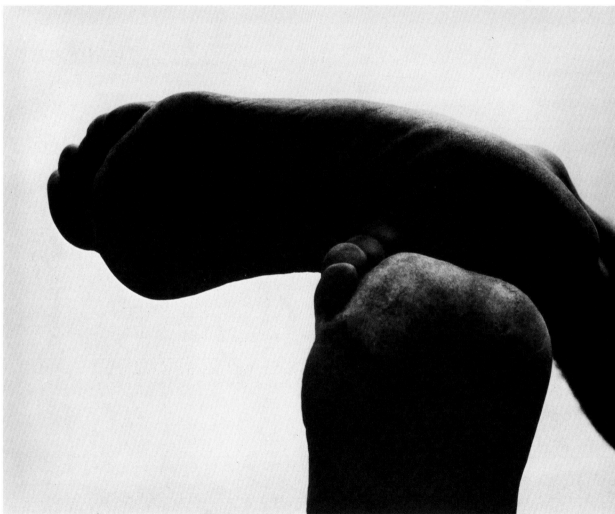

AARON SISKIND: *Feet,* 1957

Form, like texture, is a three-dimensional quality; to reveal it in a two-dimensional picture, the photographer must be alert to the features of a picture that convey the depth in a subject — above all, the way that light and shadow fall across a scene to bring out all of the contours.

Form may be accentuated to express a subject's identity and function, as in the statuesque image at right. On the other hand, form may be emphasized for its own sake, simply to celebrate the intrinsic visual interest of an object's contours.

The human feet above were deliberately removed from their anatomical context to arrive at an image that attempts no literal communication but is simply a striking arrangement of solid objects.

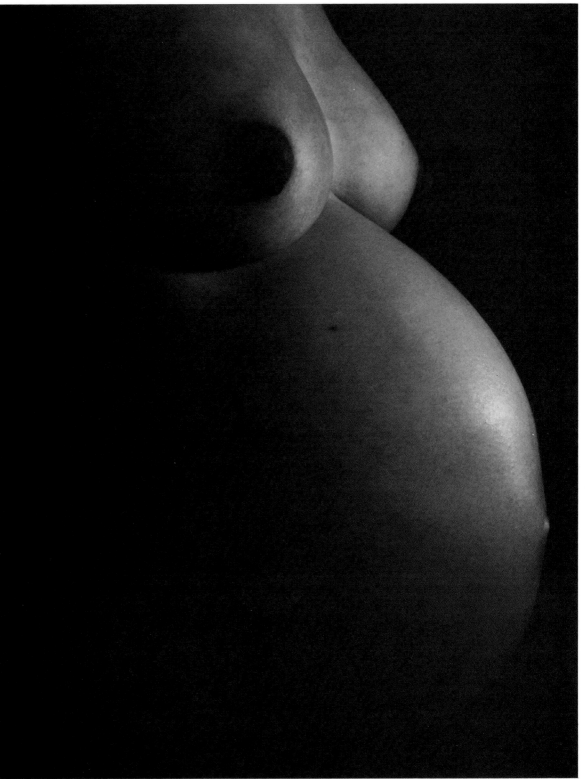

Sculpted by soft daylight and slight additional floodlighting, the swollen form of a pregnant woman becomes a compelling symbol of the fruitfulness of life. Barbara Morgan gave the final print a predominantly dark tone to create a sense of the "mystery and beauty of childbearing."

BARBARA MORGAN: *Pregnant,* 1940

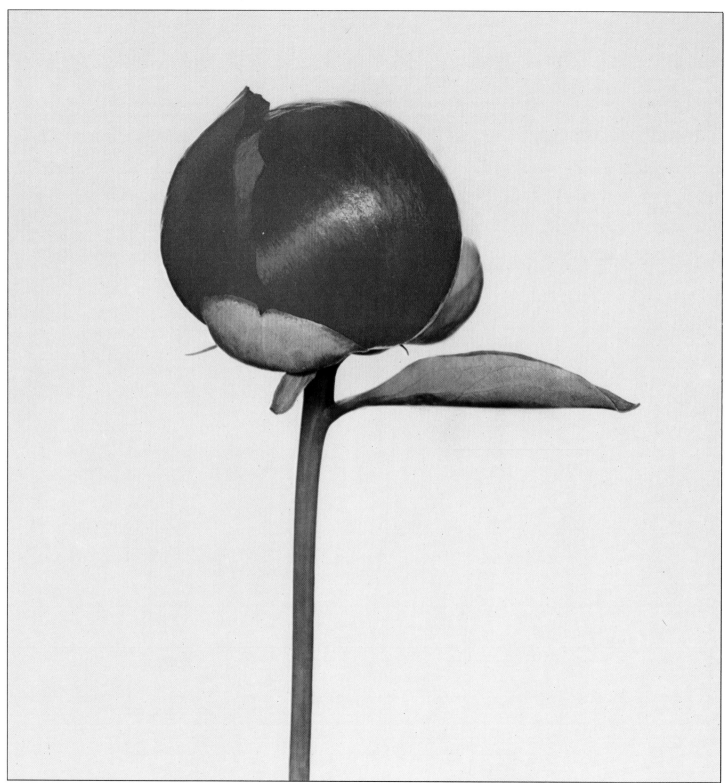

IRVING PENN: *Hari-ai-nin,* 1968

40

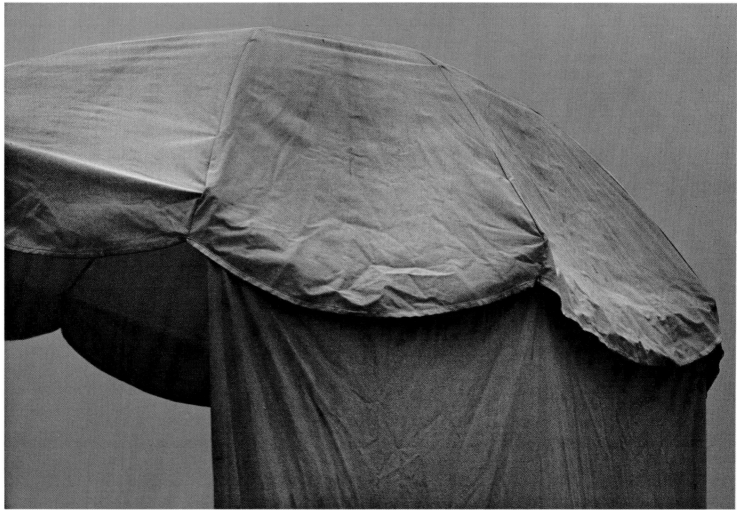

JOHN BATHO: *Bâche Ocre Jaune,* 1977

◄ *A glistening highlight and the curvilinear shadings of richly colored petals signal the roundness of an unfolding peony bud, a Japanese variety. The spare lines of the stem and leaf, which seem almost flat against the blank background, serve further to set off the bulging contours of the furled flower-to-be.*

The familiar form of an umbrella tent seems to float against the sky at a French beach resort. Isolating the subject in this way separates the tent from its conventional function and concentrates attention on details of form: the wrinkles and drooping folds of the fabric, the depth of the shaded interior.

Arresting Colors

Introducing color to photography broadens creative possibilities by employing the most compelling quality of vision— but it also demands subtle judgments to get the most out of this addition. Too much color, inappropriate color or unsuitable color relationships can all do violence to a photographer's intention.

Yet once the challenge is met, color adds another dimension in visual boldness. Colors can be selected, concentrated or muted to create a degree of perception scarcely available to the eye in its routine scanning of the world.

Colors can provoke an emotional response: The bright reds and oranges are generally associated with heat or passion, the blues and greens with coolness and gloom. Muted tones of the same color, as in the portrait at right, create a calm contemplation. Tones of the same color have another effect as well: Dark, rich shades are usually seen as being nearer to the viewer than pale or washed-out shades. This is largely because in everyday experience atmospheric haze tends to wash out colors of distant objects.

Colors appearing side by side in a picture can interact and affect the way they are seen. The eye has slightly different focal lengths for different wavelengths of light: Long, red wavelengths are focused on a point slightly behind the retina; short wavelengths of blue or green slightly in front of it. As a result, red objects in a picture appear to be nearer the eye than objects of blue or green in the same picture. Reds are said to "advance," blues and greens to "recede."

When bright reds are juxtaposed with blues or greens in a photograph, the result is a kind of optical vibration as the eye tries to keep both colors in focus, as in the picture opposite.

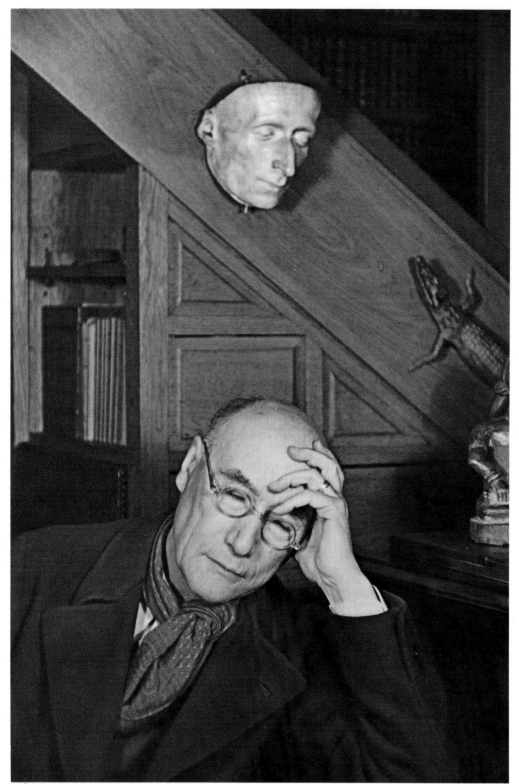

GISÈLE FREUND: *André Gide,* 1939

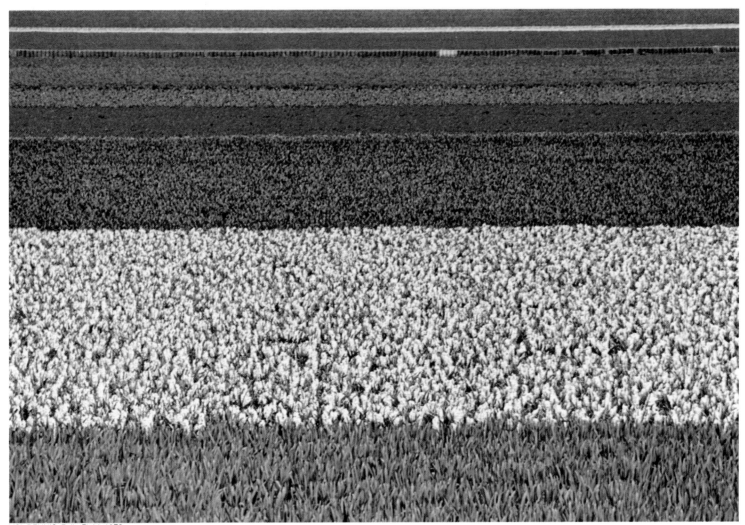

LISL DENNIS: *Tulip Field*, 1978

◄ *The use of only a few colors creates a subdued mood in this portrait of Nobel prize-winning novelist André Gide, sitting pensively in his Paris study beneath a mask of a 19th Century Italian poet. The monochromatic mood is the result of the scene's uniformly warm colors and the effect of lamplight on the film. The photographer used early Kodachrome film, which produced unusually warm tones when exposed under incandescent lights.*

Beds of Dutch tulips glow in a bold abstraction of vibrant contrasts. The rapid adjustments the eye must make to focus both red and green wavelengths may give the viewer a sense that the contrasting bands of color are quivering or vibrating, an impression that heightens the impact of the image.

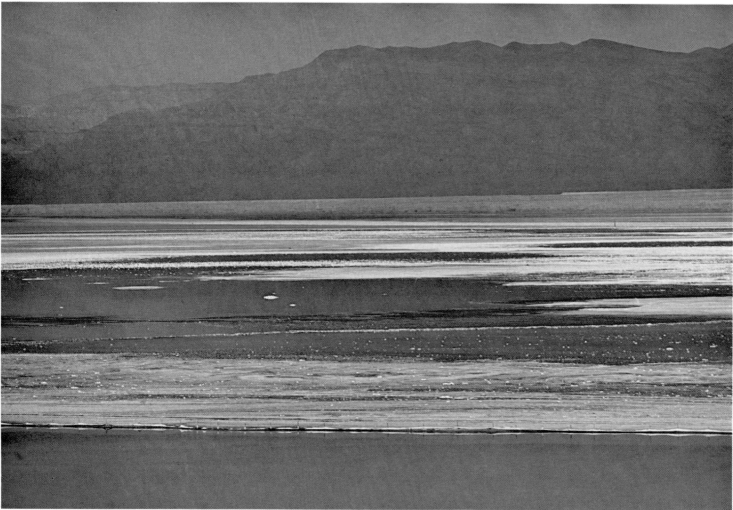

GAIL RUBIN: *Dead Sea,* 1976

*Sunset gilds the water at the edge of the Dead
Sea between Palestine and Jordan and turns the
water farther offshore almost silver. The rich
orange tones not only suggest the waning heat of the
day, but because they seem to advance toward
the viewer, they bring the foreground nearer
and enhance the sense of distance across the
water to the looming mountains beyond.*

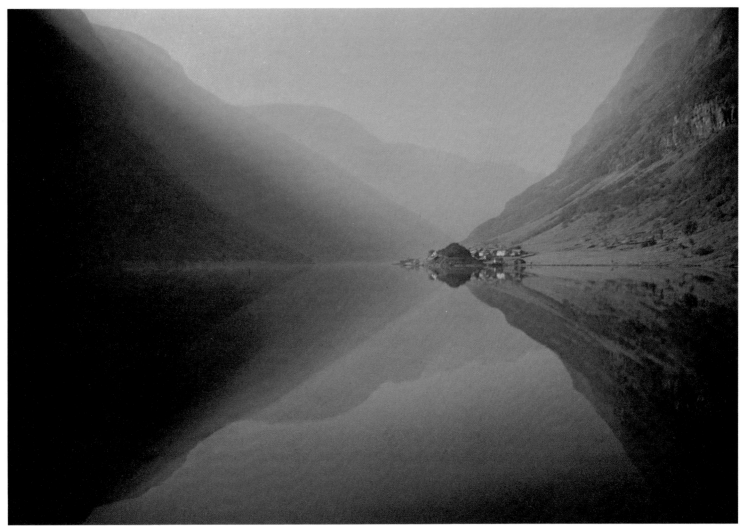

ERNST HAAS: *Hardangerfjord,* 1959

In a view of Norway's Hardangerfjord taken on a windless autumn afternoon, darker blues of the nearby coastline seem to move toward the viewer, while the pale colors of fjord walls farther off seem to fade away. This phenomenon, linked to atmospheric conditions that normally wash out objects, imparts a sense of limitless, cold distance to the photograph.

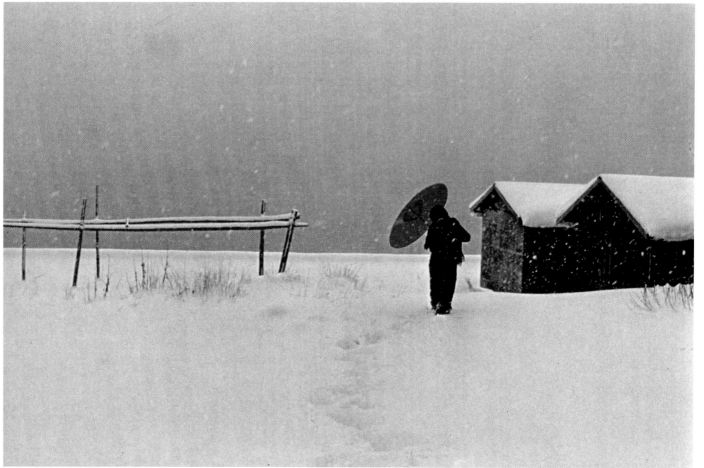

EBERHARD GRAMES: *Woman with Umbrella at a Sea,* 1978

Like a figure in a dream, a woman carrying a parasol walks toward farm outbuildings through a January snowfall in Japan. The muted range of grays and the pencil tracery of weed stalks express a feeling of bleak wintery cold. This sets the stage for the one spot of color that dominates the scene: a vibrant red parasol. It seems to float above the figure of the woman, giving her and the otherwise dreary image a touch of jauntiness.

An elegant old Manhattan apartment building rises like a confection of brick, stone and glass against an industrial waterfront district. The photograph is filled with color across the full rectangle of the frame, attracting the eye to every detail of the richly variegated scene, from the building's cozy interiors to the streams of commuter traffic on the highways beyond.

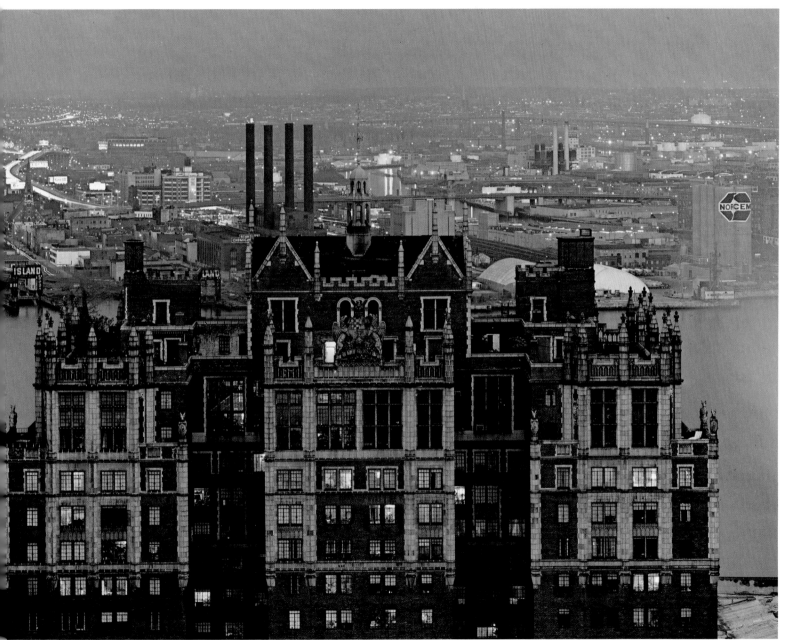

REINHART WOLF: *Tudor City, New York,* 1979

The Visual Elements in Combination

Shape, form, pattern, texture and color are fundamental elements of photography—and concepts that help to explain how pictures work and how to make them better. But in the world as seen through a camera viewfinder, the scene composed entirely of textures, or solely of fields of color or flat shapes, or of any isolated visual element, is a rare one indeed.

Far more likely, the scene under consideration will contain most of those basic elements, and may exhibit several of them prominently. The photographer then must decide whether he wishes to isolate any one of the elements or to record them in some combination. He must base his decision on his judgment of what it is about the subject that makes him want to take its picture, and how that element or those elements can be made to evoke a similar response in the viewer of the finished photograph.

Whether he comes to his decision intuitively or through deliberate analysis, he must determine which elements help the picture, and which hinder it. For any picture, the best combination of elements will be irreducible—the minimum that will express the photographer's sense of the subject. The picture here and those on the following pages evince such a combination—one that respects the possible visual complexities, yet at the same time pares away all but the essentials.

Graceful form, blazing color and a sharply delineated shape combine in this striking picture of wind-sculpted dunes undulating across the Sahara. Late afternoon's strong crosslighting accentuates the contours of the dunes, which create a series of angular forms dominated by the pointed triangle that opens into the orange glow of the nearest dune. The sand's advancing color approaches like waves of heat, while the sky's receding blue, deepened with the aid of a polarizing filter, appears infinitely distant and cool.

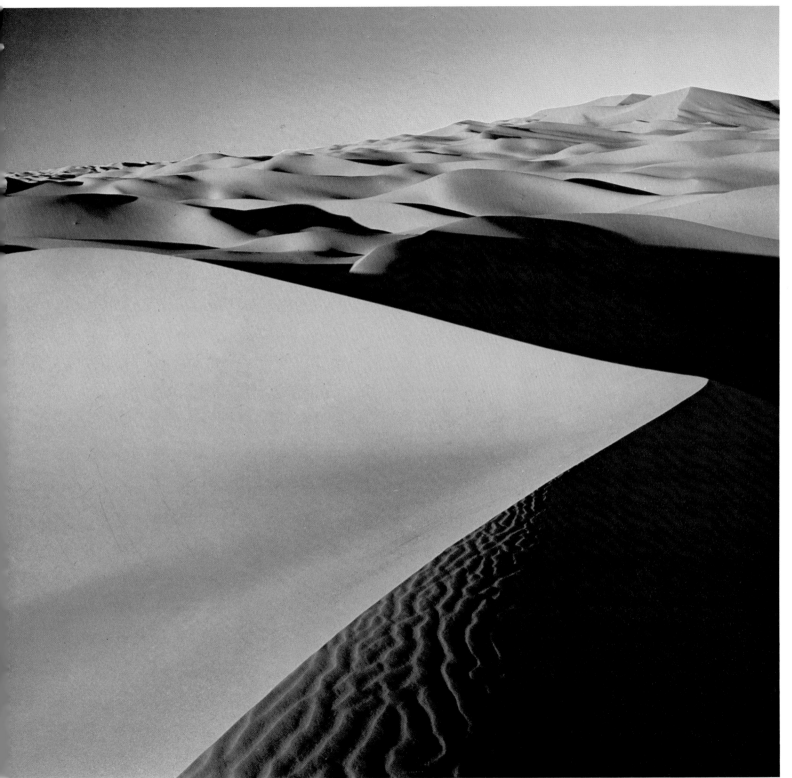

KAZUYOSHI NOMACHI: *Grand Erg Occidental Desert, Algeria,* 1973

MINOR WHITE: *Dry Stream Bed*, 1967

A dry stream bed in Utah has become an abstraction of texture and shape in this picture, taken with a portable view camera and printed on high-contrast paper. One component of seeing has brought another into being: the soil texture, darkened in different ways by the angle of the sunlight, forms a rich variety of shapes.

A picture of frost crystals on a bedroom window ▶ (right) makes a tapestry out of a mixture of pattern and texture. Positioning his view camera about a foot from the glass, the photographer stopped the lens all the way down to f/32 so as not to lose the dark trees in the background.

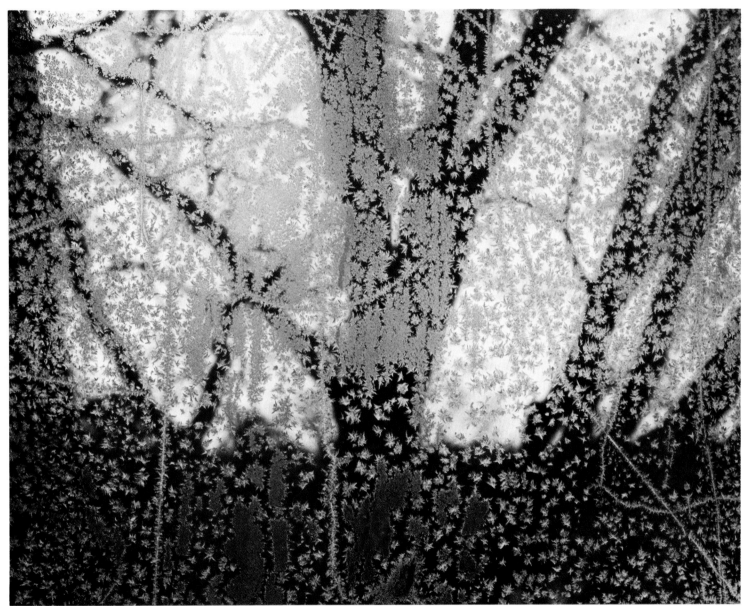

PAUL CAPONIGRO: *Frost Window No. 2*, 1961

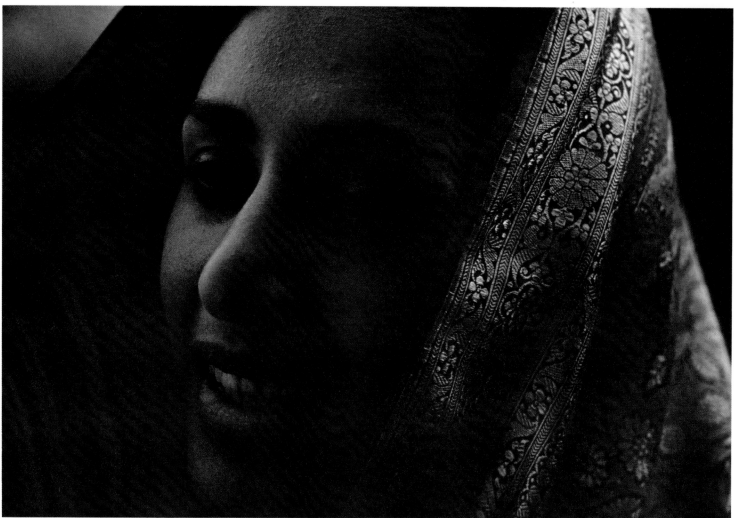

ERWIN FIEGER: *Goshi,* 1963

*A Pakistani woman smiles beneath her shawl in a
picture that depends on practically all of the visual
elements to convey the beguiling mystery of the
East. Warm colors, the texture of her skin and
lips and the flash of her teeth and darkly luminous
eyes reinforce this mood, while the rich texture
and pattern of the shawl's intricate embroidery set off
the rounded form of the woman's face.*

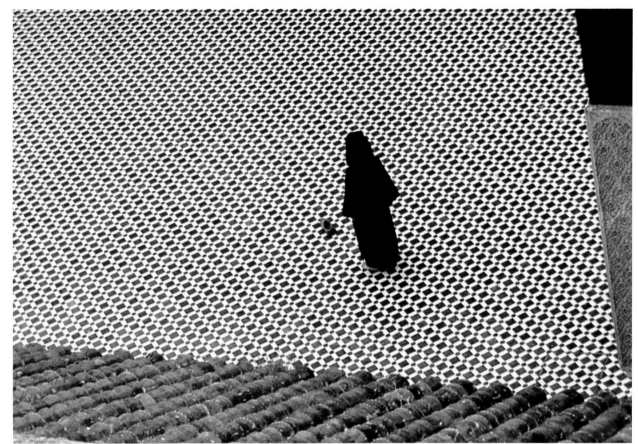

HARRY GRUYAERT: *Man in Prayer*, 1976

Ribboned columns of terra-cotta roof tiles lead
the eye downward to another vibrant pattern
of ceramic tiles in the courtyard of a Moroccan
mosque. Alone in the middle is the shape of a
cloaked man, barefoot as a sign of respect. The
repetitive design of the roof and floor tiles heighten
the isolation of the solitary figure.

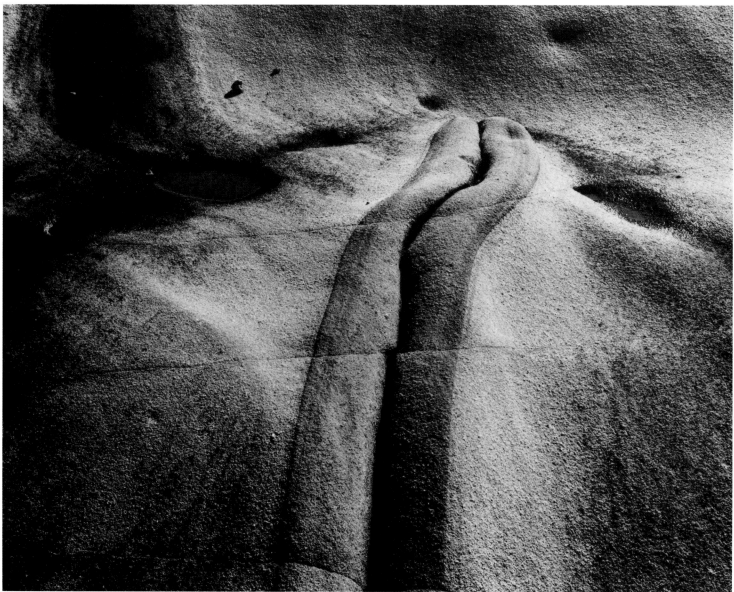

MINOR WHITE: *Long Form Moving Away*, 1950

Straight-edged except for its single curving boundary, this combination of patterns and shapes of shadows comprises an intricate visual fugue in the study at right. Counterbalancing designs make a mystery of the subject's identity.

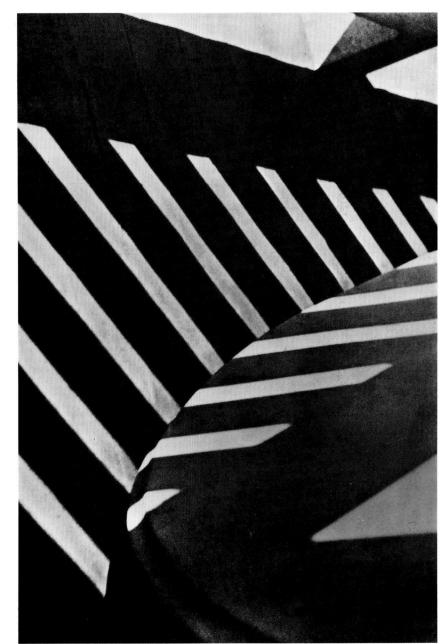

◀ *Sensuous texture and complex, shadowed forms dominate this picture of sandstone at Point Lobos, California, whose water-sculpted rocks have fascinated countless photographers. Here the photographer has produced a study in high contrasts, ignoring the overall shape of the rock.*

PAUL STRAND: *Shadow Patterns*, 1916

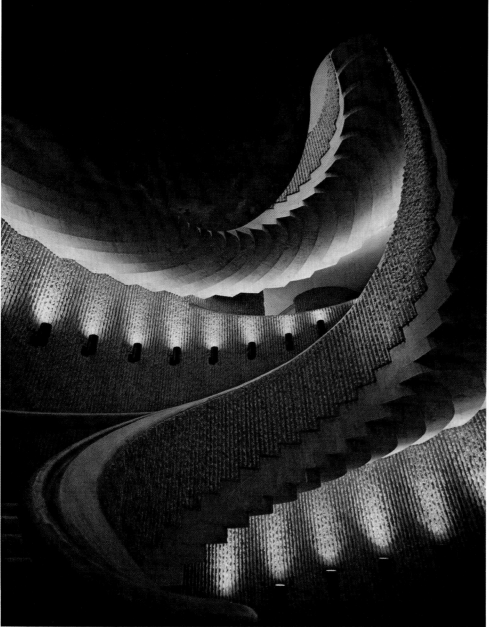

In a swirling abstraction of patterns, textures and forms, a spiral staircase in a health center in Boston glows like the interior of some giant incandescent nautilus. The photographer used daylight color film, which produces unusually warm tones when exposed under tungsten lighting, to turn ordinary concrete into a stairway of burnished gold.

ROBERT PERRON: *Boston Government-Center Stairway,* 1973

Principles of Design **2**

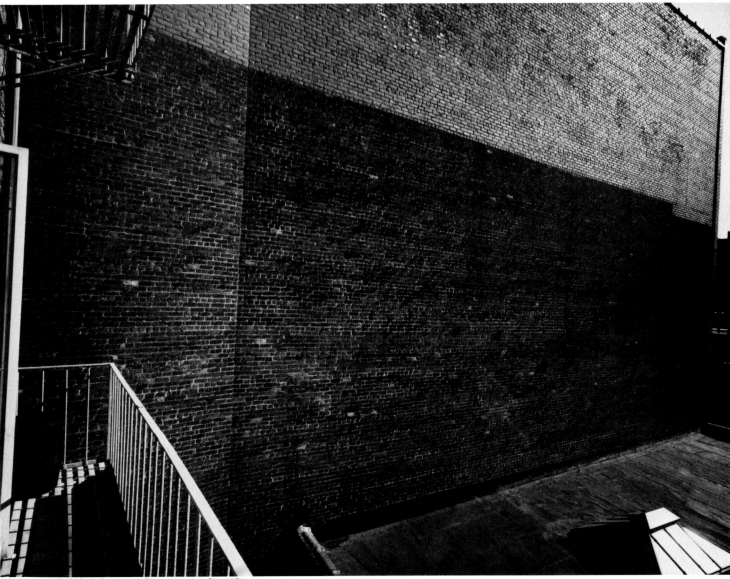

WOLF von dem BUSSCHE: *Christopher Street, New York City*, 1971

Making Design Work

Design in photography is sometimes thought of, mistakenly, as a repertoire of tricks for beautifying pictures. That idea is as false as considering architecture to be merely the embellishment of the outsides of buildings. In photography—as in every art and craft—design is the process of organizing ingredients so that they achieve a purpose. A teapot, for example, is a device that must be light enough to be picked up in one hand, that must contain a liquid, keep it warm, pour it without spillage, and satisfy a number of other requirements as well. The design of a teapot reconciles all these requirements through a particular choice of material, shape, thickness and other qualities. It makes the teapot work.

What makes a photograph work is also complicated. A picture is something that works by being perceived. It is usually (not always) a flat object that is meant to communicate something to a viewer. More often than not, that "something" is quite complex—a blend of feeling, information, insight and idea that would be difficult to sum up in words. Good design in photography is any structure—any organization of visual elements—that enables the beholder to grasp all that the photographer wanted to communicate.

Design accomplishes this, in part, by subtly making the viewer want to grasp the picture, by inviting his eye, and thus his sensibilities, along something of the same route that the photographer himself took, cerebrally and emotionally, in making the photograph. Without design, a picture of a brick wall like the one on the preceding page is just another record of a blank brick wall, but with design it is not so blank at all. Instead it becomes a study of pattern and texture, charged with subtle dynamics of balance between light and shade, tension of line and form, that may or may not be intended to convey a precise meaning, but that through its design operates independently, uncaptioned, as a visual communication of the photographer's feelings and thoughts.

Assuming that every picture needs some sort of structure to achieve its purpose, how does the photographer bring about this organization? Most likely he will make a number of broad design decisions without even being aware of them. Simply using a camera is one such decision: It will form an image in perspective—that is, it will make distant objects appear smaller than near ones, and it will make parallel lines seem to come together as they recede from the camera. Most photographers take the perspective-rendering camera for granted. But there are design alternatives, such as montages, in which distance need influence neither the size of objects nor the convergence of lines in the way we have come to expect.

Film and printing paper—as well as exposure and development—also help design a photograph by responding to light in a characteristic way, each material and each technique for using it introducing its own qualities: contrast, color rendition, graininess and so on. The photographer may want to venture be-

yond the ordinary uses of film and printing paper by sandwiching negatives for composite pictures, creating photograms without camera or lens, or imposing various other sorts of organization on his work.

Such basic matters establish the broad framework of design in photography. They, like the painter's palette and canvas, determine what can be done next in creating a picture. Within this framework, the photographer still has an enormous number of design options for organizing the visual components to produce the effect he wants.

By changing his camera angle or walking around a subject, he can exercise great control over what will appear in the picture and how it will be arranged — choosing a background, for instance, or establishing a new relationship between two objects by making them look closer together than they really are. The selection of a lens allows him to control the effect of perspective and alter the relative sizes of near and far objects, as well as the amount of material included in the picture. (A wide-angle lens might be placed close to a piano player's hands to make them seem disproportionately large; a long lens can make cars in a traffic jam seem crammed together by rendering them almost the same size.) By adjusting the lens aperture, the photographer can either keep almost every part of a picture in sharp focus or extinguish some unwanted element in a vaporous blur. By choosing the appropriate shutter speed, he can freeze a moving object in one spot or cause it to draw a streak of color across the picture. Through his choice of lighting, he can control the brightness of a scene, its shadows, and what is disclosed or obscured. Each of these decisions helps determine which components the viewer will see in a situation and how important they will seem to him. They help set the design.

This list of techniques (by no means exhaustive) indicates only how a photographer can impose a structure on his image — and immediately raises the question of *what* that arrangement should be. There is no all-purpose answer, for the deployment of elements in a picture depends on the intention of the photographer and on the techniques that are available to him. But in striving for effective communication, he can exploit certain design principles that have been known to artists for centuries and are still useful guides. Familiarity with these principles helps determine the way the viewer interprets relationships between the visual ingredients in a picture. It is the relationships, rather than the separate ingredients, that mainly influence the way the viewer perceives the picture and determine its success as a design.

Viewing a picture, people will note differences or similarities among its parts — variations in shape, texture, form, color, size, orientation and perhaps a number of other characteristics, depending on the training and patience of each viewer. Due to the differences or similarities that are perceived, the parts seem to gain a visual equivalent of weight, and they make the picture seem

balanced or unbalanced. One part may appear to be dominant and the others subordinate. Their relative amounts— the proportions— of color, bulk or any other characteristic may seem familiar or surprising. The separate parts of the image might appear to group themselves into a single configuration, such as a triangle or circle. Or they might set up a visual counterpart of the rhythm that is associated with motion and sound. And even if there were only one element in the photograph, its size, tone and position in the frame would stir some associations and comparisons in the viewer and evoke mental relationships.

Why are human beings so responsive to such visual forces and relationships? Many explanations have been offered. The impulse to interconnect visual ingredients so that they will have meaning is, perhaps, a basic function of intelligence. We survive by constantly trying to organize and make sense out of what we see, identifying and assessing visual data for dangers, food or whatever. When we see a man running in the street we may merely be curious; but if we relate him to a following runner dressed in a blue uniform, the visual data acquire new meaning, and curiosity may change to alarm. Why we seek certain meanings, searching a picture for particular relationships such as balance or rhythm, has been explained to a degree in physiological terms. As two-footed creatures who have to go through a tricky period of learning to stand upright and walk, humans might well be expected to react to balance, feeling comfortable when it is present and disturbed when it is absent. People appreciate regular rhythm, perhaps because of the inspiration of the countless rhythms that appear in nature— the heartbeat, the alternation of night and day, the pulse of the waves and the phases of the moon. But these physiological preferences may be less explanatory, many psychologists believe, than the general method of operation of the human brain, which seems always to seek to organize visual data into the most simple, regular and symmetrical configurations possible.

All these theories may possess a measure of truth. And they pose an intriguing possibility in the matter of design. If the brain, for whatever reasons, likes unity, regularity, good balance and steady rhythms, why not arrange the ingredients in every picture in a way that provides these relationships and nothing else? The answer usually given is obvious: In addition to the need for clarity, order and balance, there is also a need for stimulation — which can be supplied in pictures by elements of variety and tension. By this reasoning, the ideal design is one that is clear, orderly and balanced — but not in too obvious a way. It should be precarious and varied enough to be interesting, but not so precarious as to be irritating. Yet even this more complex formula fails on close inspection. It would sacrifice a great deal of the expressive power of design. For instance, an unbalanced structure might well be the best design for a picture whose intent is to disturb. Strange pro-

portions can be extremely revealing — as in the example of the pianist's hands made to look unnaturally large. No other familiar relationship need be present: A photograph that is all color or pattern, with no dominant element, may be just as effective in communicating a creative intent as one with a more conventional scheme.

The effort to find an ideal design scheme has a long history. The Greeks, believing that certain proportions had divine significance, considered the so-called Golden Section rectangle, with a ratio of roughly 5 to 8, to be perfect. From Classical times to the present day, artists have devised formulas for relating design to the proportions of the human body. And some manuals of photography have listed rules prescribing, for example, that a horizon line must never divide a picture into equal halves, but ideally into two thirds/one third. Yet for every allegedly ideal arrangement, innumerable fascinating exceptions can be cited. It is safer to say that good design is any organizational scheme that communicates effectively.

For a beginner, good design usually requires cautious, conscious decision making. As he grows more experienced, he will learn to organize the elements as efficiently and perhaps as automatically as shifting gears in an automobile. This was the case with the photographs on the following pages, taken by Wolf von dem Bussche. His fundamental design decisions remained more or less constant throughout: He used a 4 x 5 view camera equipped with a wide-angle 65mm lens to shoot the black-and-white pictures, which he printed on medium contrast paper. For the color pictures, he chose a 35mm camera and color reversal film. But within the various pictures, he deftly exploited a number of different kinds of pictorial arrangements to strike sparks of comprehension and interest in the viewer's mind. □

The Dominant Feature

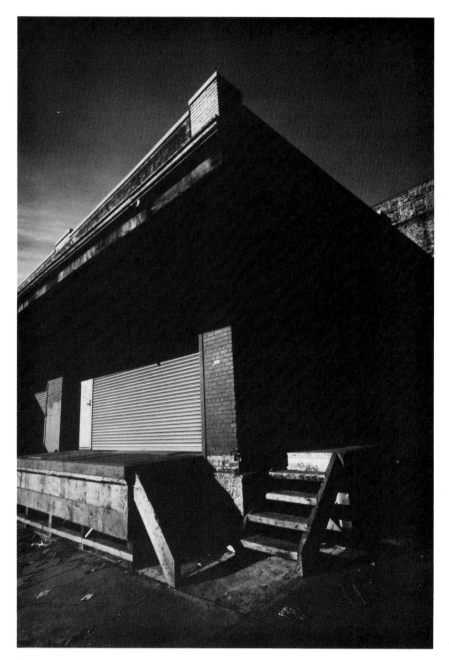

A design may organize the elements of a picture in a number of ways—through balance, proportion, rhythm, form or color—but often one mode of organization will prove more effective than the others. In both of these pictures, the visual components are chiefly linked in a relationship of dominance and subordination. The result in each instance is an image charged with underlying tension but one that also, like the works of a fine watch, embodies a powerful unity.

The subject at left is a loading dock. It is, on the face of it, an uninspiring subject; if it were depicted from another angle or with less contrast, it would probably bore the viewer. But Wolf von dem Bussche chose his vantage point near a corner and used a wide-angle lens to make the lines of roof and platforms converge sharply, revealing the building as a kind of jigsaw puzzle of irregular polygons. He then emphasized the polygons by setting his exposure so that the shadowed areas within them came out very dark. Because the shadow under the roof is the largest and darkest of the polygons, it is dominant, and all of the other polygon shapes are subordinate to it.

In the photograph at right, a different technique for generating dominance has been used: Although the background of the picture is occupied by a spectacular fire, red flame only partly obscured by clouds of black and white smoke, the viewer's eye cannot resist looking at the rather ordinary electric pole because guy wires and transmission lines lead directly to it. Manipulation of position, light and color reinforce the pole's dominating effect: The pole is placed front and center in the frame, sunshine spotlights the crossarms and dissects a pale plume of smoke rising from the blaze behind it.

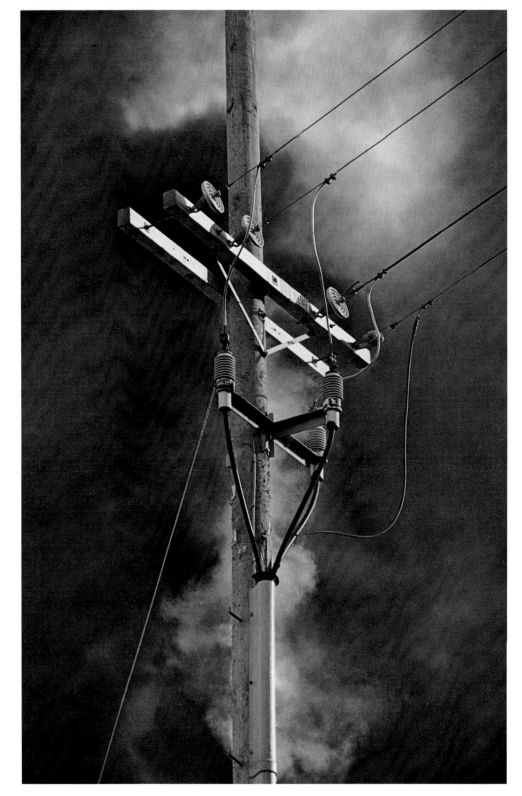

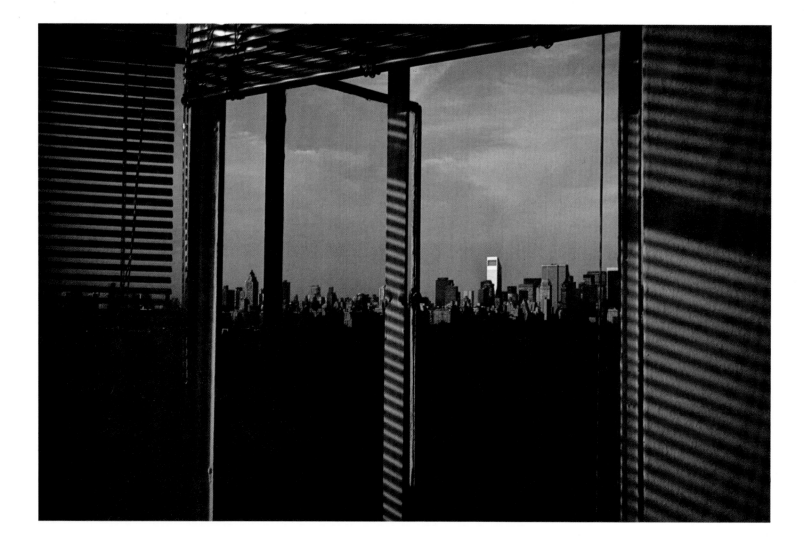

Some pictures achieve their effects with very formal and obviously balanced designs — an image with identical halves, for instance. Other photographs have a subtler, asymmetrical balance produced by interactions of visual components.

Balance need not depend on matching sizes or shapes. Instead, it may result from the relative weight the photographer accords each pictorial ingredient. Pictorial elements achieve visual weight — and demand viewer attention — according to size, color, location or interest. And these demands may add up to equilibrium by perceptual calculations almost impossible to explain in words. But no matter how balance is achieved, it evokes a sensation of stability and comfort in the viewer — and this response may well suit the photographer's purposes.

Both of the pictures on these pages are asymmetrically balanced. In the photograph of the house behind the fence at right, equipoise has been established by ingeniously playing off size against visual interest. Almost all of the picture is taken up by the fence. But the old-fashioned, angular house is much more intriguing than the fence, which is blank except for a wavelike chalk line. This size-versus-interest rivalry for the viewer's attention ends in a standoff that is stable but definitely not static.

At left, visible through a New York City apartment window, is a frieze of silhouetted skyscrapers lacking the visual weight to match the dark shadows of Central Park in the foreground. But as the sun sliced across the window frame it turned a lone building on the horizon into a gleaming white spire. This single sunstruck surface was all that was needed to counterbalance the shadows dominating the foreground.

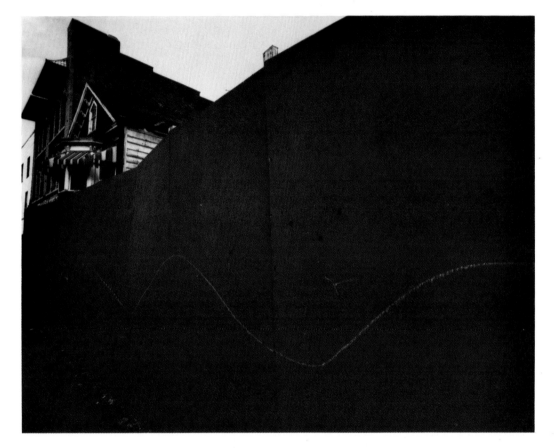

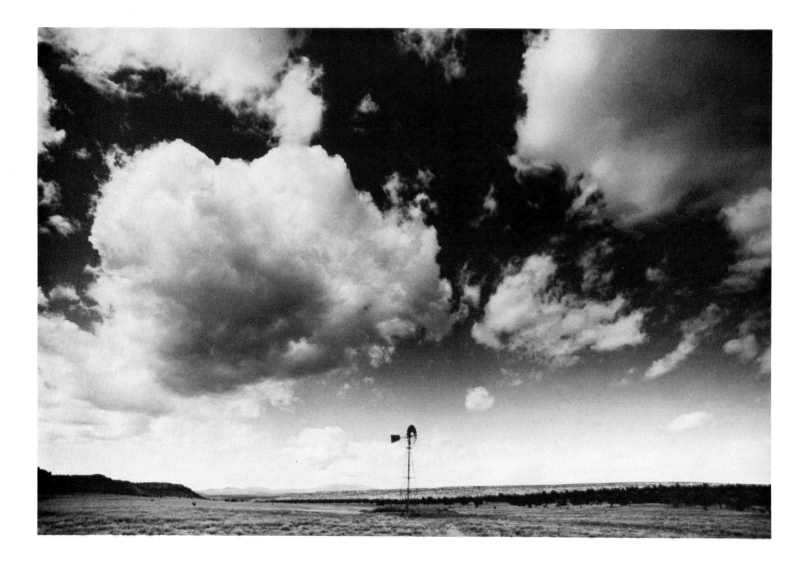

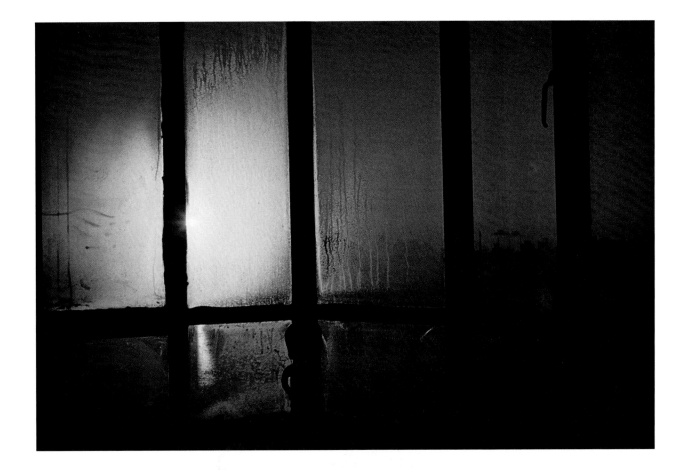

When a line is divided into parts, the ratio between them is a proportion. Similarly, a ratio can be struck between comparable elements in a picture, defining a visual relationship that may depend on qualities as objective as size, number and color, or as subjective as tone or interest. (The balance of the parts, and their dominance or subordination, are other considerations, although proportion can influence either.)

The pictures on these pages are radically different in subject matter and composition, but proportion underlies their visual dynamics — and each depends on a ratio of skyscape to earthbound subject matter to work.

A sliver of earth anchors a vaulting sky puffed with clouds that dwarf the tiny windmill etched against the lonely horizon at left. It is the proportion of the picture occupied by that enormous sky that makes the windmill and the dirt road leading up to it appear so isolated.

At right, nearly equivalent proportions lead to an effect of tension because the five vertical sections of the silhouetted window frame are almost, but not quite, balanced. The tension is reinforced because the warring parts of the photograph contain contrasting colors: blazing orange sunlight on the left, cool blues on the right. This contrast in colors leads to an interesting paradox: Because of it, the smaller but brighter part of the picture captures the viewer's attention.

Rhythm

The word rhythm comes from the Greek *rhein,* meaning "to flow," but it implies a flow with a recognizable pattern. In musical compositions, a patterned flow is obvious, since such works of art are performed over a period of time. The visual arts display this rhythmic property too, even though most pictures exist as a whole, not changing with time. They gain their flow—and rhythm—because they are perceived over a period of time, as the viewer's attention moves from point to point.

Rhythm is created whenever similar pictorial components are repeated at regular or nearly regular intervals. The viewer's attention is lured through the image along the path of repetition, and the result is a sense of order and unity. In addition, visual rhythm may help to build a kind of viewing efficiency into a picture, in the same way that playing tennis or chopping wood is easiest when done rhythmically.

A rhythmic design was used to organize the photograph at right. The recurring component is shape. The viewer's attention repeatedly leaps the dividing line of the fence top to take in the shapes of a torn patch in the fence, a windowed house, another torn patch, a tree, yet another torn patch, and the roofs at the sides of the picture. Underlying this alternation is the less pronounced but more regular rhythm of the dark markings on the fence, stitching a bonus of order into the design.

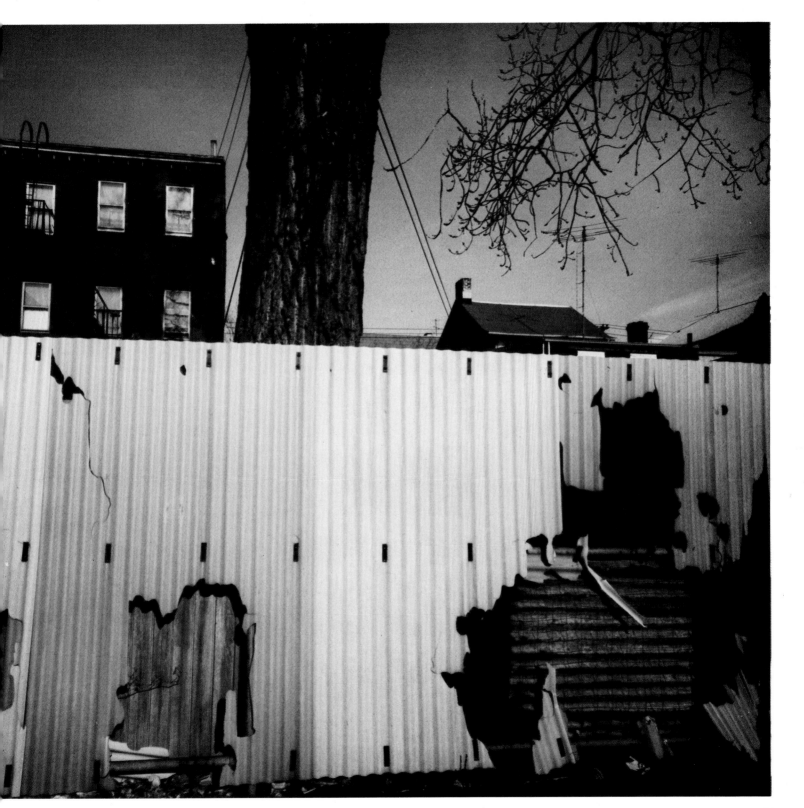

Perspective

Perspective, by making objects appear to shrink with distance and by making parallel lines seem to converge toward a point on the horizon, creates the illusion of three-dimensional space in a photograph. It supplies clues—object size, line convergence, texture—that the brain interprets as indications of depth.

While a camera is constructed to produce perspective automatically, a photographer can either call on this sort of depiction or suppress it. The straight-on shot on the preceding page, for example, gives a scant impression of depth because it contains so few lines that converge toward the horizon. But the photographs on these pages rely heavily on convergence: A perception of depth underlies their visual impact.

The landscape at left flaunts perspective clues: the relative sizes of house and fence, the converging lines of the fence and utility wires, and the loss of detail in the texture of the grass, fence and tree limbs as they recede from the foreground. In the picture of the sun setting behind New York harbor *(right)*, it is not line but color that establishes clues to depth and perspective. The most intense color—the sun itself—draws the eye toward the vanishing point on the horizon, establishing it as the picture's center of interest.

Other clues help establish perspective: A finger of reflected sunlight points directly at the vanishing point, and twin pilings in the foreground target the sun between them. One final clue anchors the picture's interest at the horizon line— the distant image of the Statue of Liberty, poking up to the left of the sun.

The Many-Element Design

Many effective photographs use more than one sort of design structure. The photograph above of a bus stop in Villahermosa, Mexico is visually organized with both vertical and horizontal components. The horizon line sets up a neat symmetry between light parts of the picture and dark. But within that balance is another relationship between the drooping fronds of the thatched sunshade in the background and their visual echo, the sunlit leaves in the foreground.

The eye is then drawn across the frame by the poles of the sunshade, which divide the picture into framed tableaux. The shapes of the people, as they await the arrival of their bus, suggest boredom, impatience and anticipation. Time, too, has become an element in the design.

Uniting all these elements is the soft crosslighting of the setting sun. It falls across the picture from the right, striking each element in turn—gathering them into a unified composition. ☐

HAROLD ZIPKOWITZ: *Antique Mannequin*, 1971

The Personal View

In a sense, photography is built upon a foundation of prejudice, because vision — the basis of picture taking and picture viewing — always involves interpretation. Seeing with absolute objectivity is impossible for the human eye: The experiences, emotions and attitudes of the viewer affect what he sees.

Whenever a camera is carried to a certain place, aimed in a certain direction and triggered at a certain instant, the photographer is being guided by his own personal sense of what fragment of the world deserves recording. The visual components of the subject he chooses — and the way he synthesizes them — will be determined by what he thinks and feels. Whoever views the photograph will, of course, add his own interpretation — and the impact of any picture is an unpredictable blend of the responses of both photographer and viewer.

This factor of personal response is often unappreciated or underestimated by both those who take pictures and by those who view them. When photography was invented, early in the 19th Century, the mechanical feat of recording images with light so astonished the public that the human element was understandably overlooked. It was thought that a camera independently turned out a good picture every time an exposure was made, and one reporter even described the new technique as a "self-operating process of Fine Art." Most people, however, gave the daguerreotypists a grudging measure of credit by calling them "conductors" or "operators," as if they took a picture the way a factory worker might throw a switch. Even today, many amateurs resort to more or less passive button-pushing — and without a qualm, they will line up to take identical "best-view" shots of Yosemite Falls or the Grand Canyon.

There is, of course, no best view, because any subject can elicit countless responses, all equally valid. For example, a college football game may seem thrilling to a sports buff, yet be boring to his wife. An alumnus, watching the game, may see his team as heroic and the other as villainous. An ex-football player may spot details in the execution of plays that are missed by everyone else. A painter might be oblivious to the flow of the game but acutely aware of the flow of colors. And each observer could well have other responses, depending on the weather, how well he slept the night before, and so on.

Any of these responses could be conveyed photographically. If the sports buff happened to be a photographer, he might suggest the excitement of the game by shooting some moment of peak action with a telephoto lens, or catching an expression of strain on a player's face. His wife, on the other hand, might communicate her couldn't-care-less response by a picture of a spectator staring vacantly at a game that is made to seem very far away by the use of a wide-angle lens. The alumnus might express allegiance to his team by including the college flag or mascot in the background of his picture. The ex-football player could emphasize the precise execution of downfield blocking by making a time exposure that traced the routes followed by the linemen.

Such approaches assume that the hypothetical photographer-observers would recognize a need to take pictures that conveyed their own attitudes toward the game. But many photographers expect a subject to divulge a meaning to the camera as if by magic, and they make little effort to utilize their own attitudes toward what they are depicting. Thus they end up with snapshots — portraits with no discernible viewpoint, landscapes that include distracting elements, or pictures of events that seem random and insignificant.

Such lack of direction is one of the most easily remedied photographic problems. The beginning photographer must make a habit of paying attention to his response, always asking himself what he feels about a subject and how he can convey his assessment in an image. With experience, this process may become unconscious — that is, so efficient and automatic that it goes unnoticed.

When the original edition of this book was published in 1971 the following pages contained a series of tests performed by 17 photographers demonstrating the role played by human response in the photographic process. In the first test, a group of professional photographers was asked to take pictures of a single inanimate object — a wooden mannequin (depicted in an intentionally neutral manner on page 77). This assignment was a sort of laboratory experiment, for none of the photographers had ever seen the mannequin before, and they were given no suggestions about what to express.

In a second test, other photographers were asked to capture the essence of "the city." Here was a subject that the members of this group had all seen before; it is, in fact, home for most of them, and they were expected to have a definite at-home feeling in responding to it. Yet few subjects could be more challenging in the sheer range of visual possibilities.

In the third test, still other photographers were asked to express "love." Instead of responding to a concrete object, as in the first two tests, these people were dealing with an intangible concept.

For this revised edition, some of the results of the original tests have been retained, while others were discarded; in their place nine new photographs appear here for the first time, reflecting changes in photographic approaches or human attitudes that have occurred since the book was first published. Attitudes toward the city, for example, have changed so much that all the photographs in that section *(pages 92-101)* were newly assigned. To express love *(pages 102-112),* four new assignments were made and two were retained from the original edition. For the mannequin section *(pages 80-91)* no new assignments were made. In all three tests, as the results show, none of the photographers failed to have a response. Still, every single interpretation was unique. Their pictures show how they utilized the principles of perception and of design that were spelled out in Chapters 1 and 2 — and also affirm that response is an essential component of the art of photography. □

Assignment: A Special Object

Your assignment is to take this mannequin and, using it in a situation, make a picture that will satisfy you creatively and communicate your reaction to the viewer.

For this assignment, which was designed as a kind of fundamental test of the importance of the response factor in picture taking, an old-fashioned wooden mannequin *(page 77)* was selected as the subject because of its basic ambiguity. Human in structure but devoid of life and gender, it represented a visual enigma whose identity and meaning were undetermined. And, in fact, it evoked remarkably divergent responses from the professional photographers chosen for this assignment. Some photographers were charmed by its age and by the effort its maker had put into carving and staining its pine features. Some of them saw it as almost human, others were keenly aware of its deadness and several photographers viewed it with distaste.

Marcia Kay Keegan responded to the mannequin in a decidedly unconventional way. Despite its artificiality, she felt that it was somehow alive, and she was determined to suggest the inaudible pulse of life within its imitation human form. At first, she thought of taking the mannequin out into the countryside to show how easily it fitted into nature. Another possibility was to photograph it in New York City's Times Square—a location whose jangled, mechanized personality would point up a placid character that she read into the mannequin.

The serenity she saw in the wooden figure impressed her most of all, and, as she mused on this quality, the answer came to her. She would pose the mannequin in a yoga position, contemplating a bouquet of chrysanthemums, as though seeking to become one with nature and the universe.

Having decided on this presentation, Miss Keegan faced the problem of getting the proper quality of light: She wanted the mannequin to show a kind of inner glow that she associated with spirituality. For a backdrop, she used yellow seamless paper. A small flashlight, covered with a sheet of yellow gelatin, was aimed at the mannequin's face. But the principal source of light was candles—eight of them placed behind the mannequin and two in front. In this warm, luminous ambiance, the mannequin is removed from the inanimate world and takes on the appearance of a living creature, filled with an air of inner peace.

MARCIA KAY KEEGAN, 1971

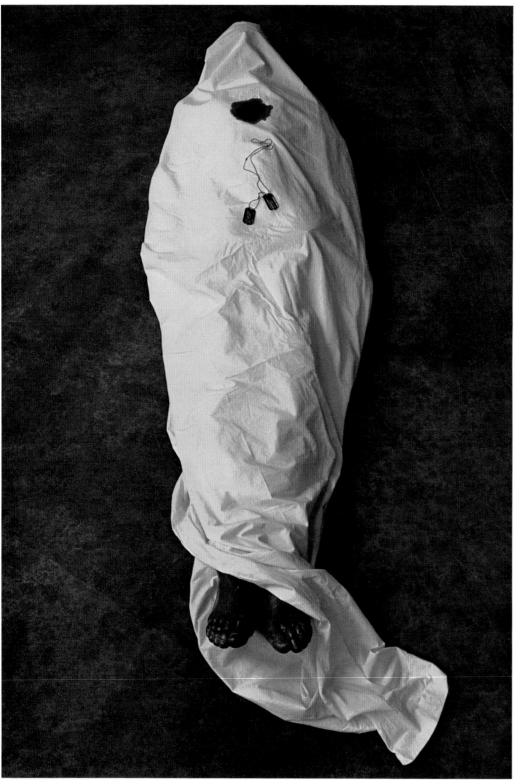

RICHARD NOBLE, 1971

Richard Noble was unsure what to make of the mannequin at first. Looking at the detailed carving of the feet, he was fascinated by their resemblance to real feet, but the rest of the mannequin seemed cruder. Overall, it impressed him as being a weird, freakish object.

Noble tried placing it in various situations—in bed, in the bathroom, slumped in a chair as if it were drunk—but the mannequin did not seem to fit naturally into any of these situations. Then, seeing it sprawled on the floor, Noble was struck by its resemblance to a corpse, and he decided to use the mannequin to make a statement about death.

Explaining how he narrowed this basic response down to workable dimensions, Noble recalled, "I asked myself, 'What's killing people nowadays besides natural causes?' I immediately thought of war. So it had to have blood. Then came the decision on where the mannequin was shot. Would it be in the leg, the face or the chest? I began to remember films I had seen in training camp when I was in the Army—especially one horrible film about chest wounds. That made up my mind."

Noble wrapped the mannequin in a sheet, arranging it so that the form would be apparent and leaving the realistic feet exposed. He placed his own Army dog tags on the figure's chest. Then he concocted a simulation of blood by mixing red and black India ink and glycerine, and daubed the shroud with it. The only illumination came from a skylight in his studio. He shot the picture from an angle that, as he put it, "would look as if you had just come upon this body and were looking down on it from eye level.

"The picture was not technically perfect by any means," he confessed. "The blood is too dark, and the sheet looks washed out in places. Usually, my work is strongly 'designed,' but I didn't want anything fancy or cosmetic here. This is a picture about war and death."

Dean Brown's response to the mannequin was strongly negative: He admired its workmanship but found it repulsive. "It's a mockery of life—deader than anything I can imagine." He decided to express this repellent lifelessness by photographing the figure on a beach, where it would seem like a strange piece of flotsam cast up by the sea.

Brown spent one whole day driving along the shores of Long Island searching for the kind of beach he had in mind. But in every setting he tried, the desired surreal quality was lacking. He arose at dawn the following day and again took the mannequin to a beach, hoping that the early-morning light would impart a strange mood to his picture—but he still sensed that he was failing to convey his response satisfactorily.

Then it occurred to him that the deadness of the mannequin might become really apparent in a place where living people dwell. He took it to the house of a girl he knew, and placed it in her living room. Again the situation seemed "faked and wrong." Then he dropped it in a long hallway; it came to rest in what he describes as an "awful position." Brown had the girl stand close to the mannequin, but something was still missing. He asked her to walk past the prostrate figure on the floor. Pleased with this effect, he decided to blur the motion slightly, using a slow shutter speed, making the girl seem more alive and the mannequin even less so.

At last, everything seemed to fit—the grotesque position of the mannequin, the cramped barren hallway and the mystery of the girl passing by. The resulting photograph, so circuitously arrived at, adds up to a deeply disturbing visit to someone's nightmare.

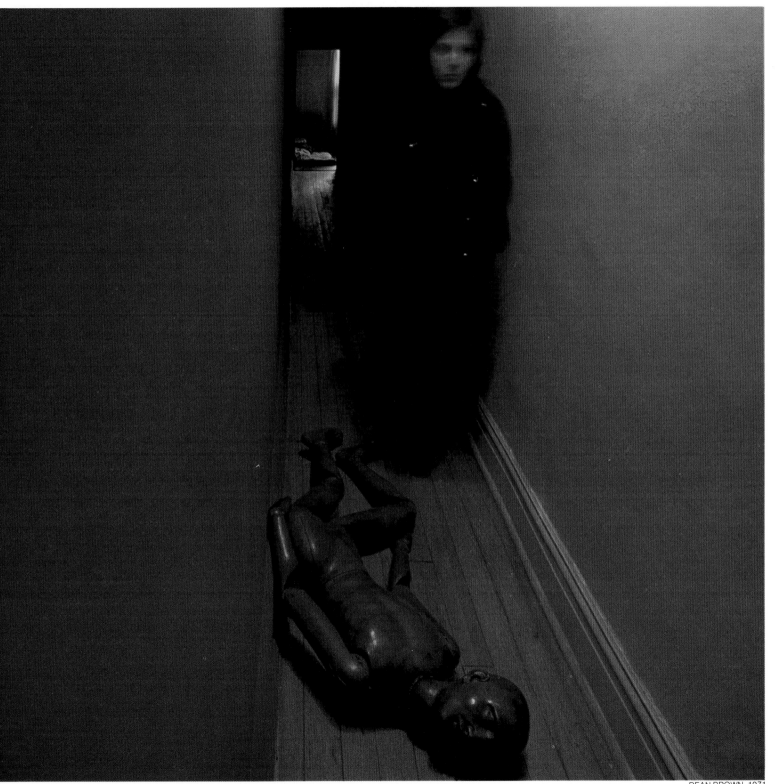

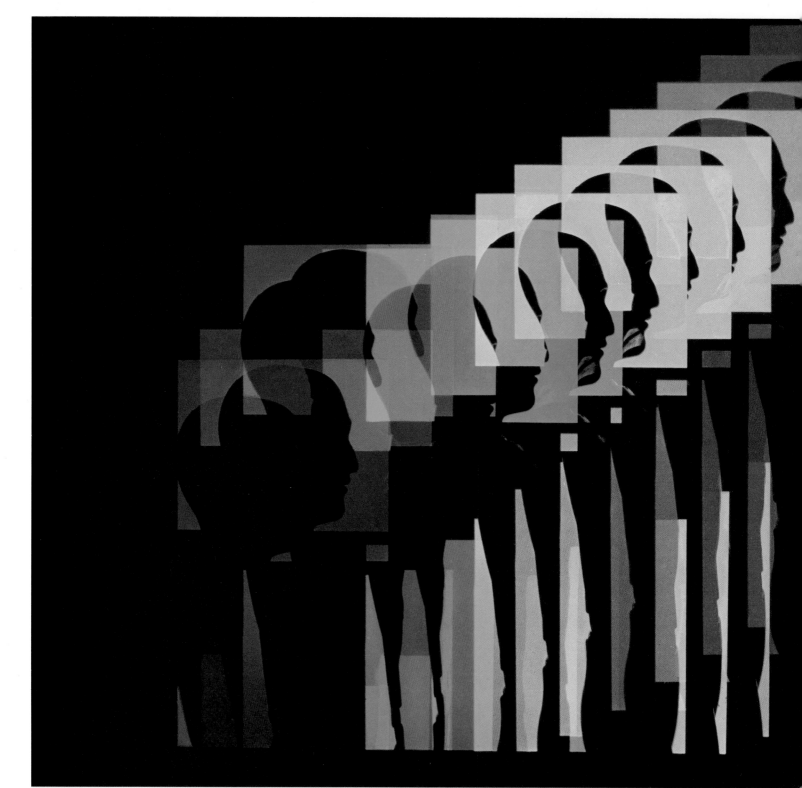

PETE TURNER, 1971

Pete Turner was not particularly moved by the mannequin. Although he liked its color and the care with which it had been carved, he did not see or feel any transcendent meaning. It remained an object in his eyes, and he had no urge to turn it into a human being or to make a comment with it.

Seeking a way to incorporate the object in a strong design scheme, he toyed with the idea of having the mannequin reflect itself repeatedly in a mirror. Then he began to notice the mannequin's age. "I knew it was old," he said, "and I had the feeling it was probably in the wrong place in time. It will probably last longer than the period of time I will live in." This idea provided the solution he had been looking for: He would use color and motion to create a feeling of time.

The picture is a tour de force of technical ingenuity. He posed the mannequin against white seamless paper. Then he hung a black curtain in front of it, and cut out a rectangular "door" through which it could be seen. To give the mannequin's head its own frame, he placed a black cardboard bar, four inches wide, across the opening in the curtain, thereby transforming the door into a Dutch door.

Turner fitted his camera with a 35mm perspective-control lens. Often used to reduce perspective distortion in architectural photography, such a lens can move up and down or sidewise (achieving the same results as the tilts and swings of a view camera's bellows) while the film remains in fixed position. It can shift the image on the film without altering image shape. Turner moved the lens in a step-like progression, exposing at intervals— with a few deviations in the pattern to keep the arrangement from being boring.

In this manner he made two identical negatives, each with eight separate exposures on it. And each exposure was shot with a different color filter. Turner then combined the two negatives into a sandwich. Where the images were identical, he printed them slightly displaced from an exact overlap in order to add variety to the pattern.

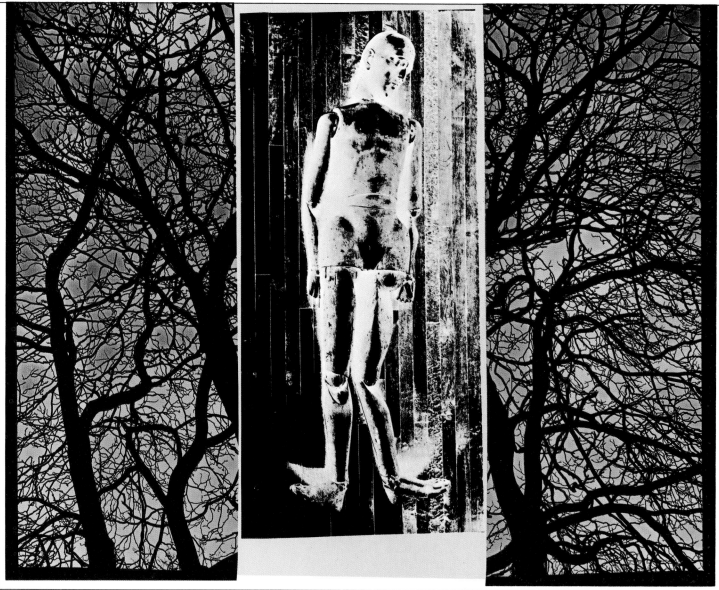

RICHARD STEINBERG, 1971

Richard Steinberg was wary of coming to quick conclusions about the mannequin, sensing that his first response might be wrong. The picture opposite was the result of a careful thought process, which he described in the following way: "You look at this dummy and he can give you the creeps. You think he can come alive, or maybe he has some kind of supernatural powers that we can never see, because he exercises those powers when he is alone in a room. Or you might fantasize that if you put a child on the dummy's lap, the child would be able to talk some secret mumbo-jumbo language to it. But I want the truth—not what something appears to be.

"I try to think about where things come from, their origins and evolution. I think about the dummy's mother—a tree that was alive with cells, generative powers, branches like ganglia, and bark with the pattern and grooves of variation and life rhythm. Somebody carved it, put it together and rubbed it.

"It was a transformation of a piece of wood into a replica of man's outer form, but the dummy is also untransformed. He is the real thing—not a replica. He is still part of a life force. Without looking at his outer form but looking at his inner form, we see his mother's branches, the flow from thick to thin, the organic layering that gives the grain a flow and pattern. And so I show you that our dummy has life—an organic life. I have rejected its outward human form by reducing it to pure black and white, a shadow of its former self."

Making the picture was complicated. First, Steinberg placed the mannequin on a wooden floor and directed two lights on it, from left and right. Using an 8 x 10 camera loaded with black-and-white film, he exposed at f/64 for 10 seconds. He made a contact print of the negative (giving him a positive image), and then copied the print on high-contrast copying film (giving him a negative). Next, the tree was shot with a 4 x 5 camera, and the negative was contact-printed directly onto copying film, yielding a positive transparency. He toned the transparency with brown dyes and cut it in half.

Finally, he assembled the three film elements on a glass plate, with the mannequin's untoned, negative image in the middle and made the picture.

Duane Michals experienced a twinge of shock when he first saw the mannequin: "It frightened me. Mannequins are very queer, bizarre things—they're imitation people made by people. When I began to work with the mannequin, I remembered a scene from a movie that I saw when I was a young kid: A boy was looking in a store window where a mechanized mannequin was putting on some kind of act; other people were watching this act along with the boy, but when it was over they left, and the boy remained alone; then the mannequin turned around and looked right at the boy. It was a very disturbing movie to see at that age.

· "I knew I wanted to work with the idea of fear and strangeness. I was interested in what the object suggests, not what it is. My initial plan was to have a real person in the picture too. Sometimes I play a game with a girl I know, where I pretend I'm a mechanical person. It frightens her.

"I decided to dress up the mannequin in one of my suits and take a picture of this girl reacting to it. Then I realized that, instead of showing the girl being frightened, I actually wanted to frighten the viewer, so I began to work with the mannequin by itself. But my idea still wasn't working. I thought, 'How can I make this work?' I took the mannequin's head off, and suddenly it all came together." □

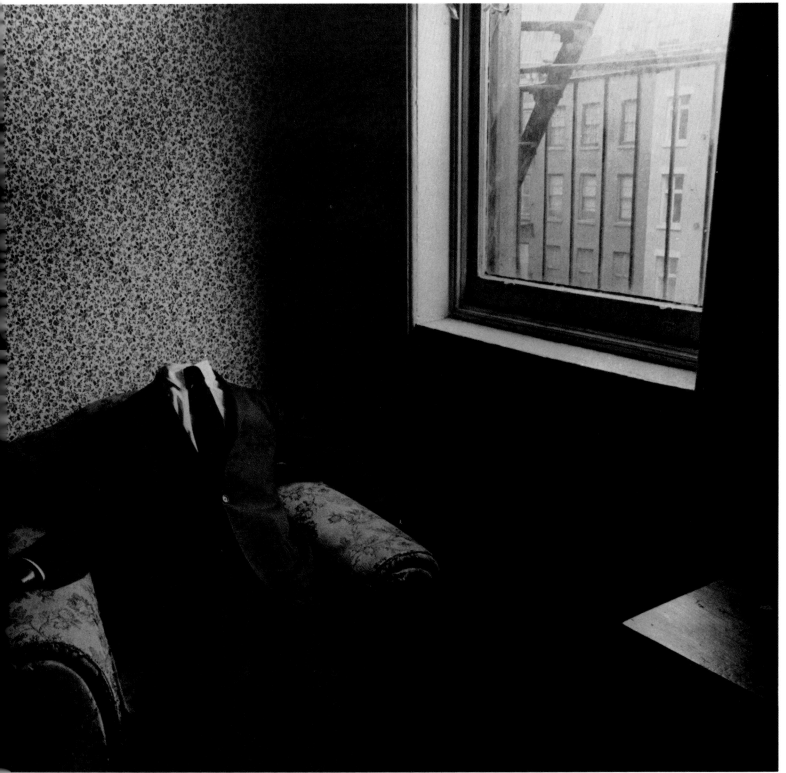

Assignment: The City

Your assignment is to make a photograph that holds for you the essence of the city.

This challenge, posed to five professional photographers, was altogether different from that involving the mannequin. Far from being a simple, inanimate object, the city is vast and complex, with an infinite dimension of fascination in its teeming populace ceaselessly working, playing, living. Yet the results of the mannequin and city assignments displayed one great similarity. Each of the photographs depends for its effectiveness— and its artistry—upon the personal vision and imaginative skill of the photographer.

To David Plowden, who chose to portray Chicago, where he now lives, the city evokes a vibrant image of "a huge, wonderfully exciting place, jammed with activity. It's not beautiful, but, rather, vital, not a showplace, but a workplace."

Stifling what he says was near-panic at the seeming impossiblity of getting all Chicago's hurly-burly into just one frame, Plowden began work by driving around the parts of the city he likes best. He dismissed the fashionable chic of Michigan Avenue as being "too much the city as great and beautiful, just a postcard." Nor, Plowden decided, did he want to show only the handsome buildings that Chicago possesses in abundance. Since he saw it as a workaday place, he asked himself, "What is an aspect that reflects the city as a center of commerce?"

In searching for his picture, Plowden found that, almost instinctively, he had headed for the Fulton Market, west of the Loop—an area that is Chicago's equivalent of the New York waterfront that he had loved to explore as a boy. As he arrived, he saw the light was just right for a portrait of the Windy City, gray and overcast, so he parked, sensing that he was nearing his picture—but still not knowing precisely what that picture would be.

While he was stalking the back streets, Plowden suddenly came upon a scene aswarm with all of "the activity, the jam, the crowdedness" that he was looking for. As a deliveryman—seen in anonymous silhouette—unloaded a truck amid a clog of traffic, with the high-rises of the city looming in the misty background, Plowden composed, focused and shot.

DAVID PLOWDEN, 1981

Sheila Metzner was looking at the Hudson River in broad daylight from the window of her Manhattan apartment when she got the assignment to photograph the city—but the image in her mind's eye, she recalls, was not the river but precisely the one reproduced at right: an enchanted Empire State Building aglow in the incandescent half-light of dusk.

New York City, Metzner says, "is my home, I was born in it," and nothing else signifies for her the magic of the city as immediately as does that towering monolith: "I've seen it in so many lights, so many times, from so many different parts of the city that I think of the Empire State Building as a symbol, a beacon, a guardian. I feel it has a certain life to it; it's almost a friend."

Because it held such visual meaning for her, Metzner had previously photographed the skyscraper, but in black and white. For this assignment, she carried a 35mm SLR and a rangefinder, both loaded with color film, and three lenses—a 90mm, a 105mm and a 300mm. With them she made her way to the roof of the building from which she had previously shot. There she worked for nearly four hours, spending most of that time preparing for the actual shooting.

She knew she wanted the picture to show the building straight on, "without any dimension and with no other buildings in front of it," and in light that is "a moment of turning, just after dark, while there is still some light. There wasn't that much time," she said, "because there was such a subtle exchange involved between the light and the dark and the lights going on. The Empire State Building lights don't go on all at once; they go on gradually."

At last Metzner was satisfied, and shot four rolls of color transparency film. After reviewing the slides, she chose the one reproduced here—taken with the rangefinder camera and the 90mm lens—and sent it to France, to have a print specially made by the Atelier Fresson, a family-owned firm that since 1890 has specialized in a process of color printing based on pigments rather than dyes.

This special process, called Fresson Quadrichromie, produces rich, full-color prints that will not fade as easily as conventional prints. To produce one, four pieces of printing paper are coated with light-sensitive potassium bichromate and pigment—one pigment for each primary color, plus one for black. Each primary color in the transparency is transferred to the emulsion by contact, so that separate emulsions exist for each primary in the slide, plus black. The four emulsions are stripped from the paper backing and repositioned, one atop the other, in perfect registration to create the final print.

The process usually takes eight weeks but to enable Metzner to meet her deadline Fresson worked with extra speed—taking just three weeks to produce a finished print. When Metzner received it, she found exactly what she had seen in her mind's eye: a portrait of the Empire State Building that transformed what is often just a visual cliché into a vibrant original image.

SHEILA METZNER, 1981

To obtain the urban vignette in the photograph at right, Grant Mudford went out and explored on foot, trusting luck—and his intuition—to spot a picture that fulfilled the assignment. "It's a difficult way to work," Mudford says. "You can walk all day and not get anything. But I am convinced that making photographs is something that can be done almost anywhere if you put your mind to it. That's part of what this photograph is all about: If you concentrate on something long enough, photographically, you can probably make a good picture out of it without relying on exotic subject matter."

To apply that optimistic philosophy to the city, Mudford found himself examining a stretch of Sunset Boulevard in Los Angeles that had frequently caught his eye as he traveled to and from his home nearby. Eventually he settled on a jumble of architectural features on the side of a brightly tiled fried-chicken stand. To Mudford, the picture works on two levels. As an abstract design, says Mudford, the picture displays "a visual integrity that is present in the scene—but which, without being isolated in a photograph, is often not realized." Also as the literal record of a place, the picture reveals exactly how Los Angeles feels to him: a little gaudy, shiny and original.

"There's a unique way things are put together here," Mudford says of Los Angeles. "Some people think it's very tacky —but I enjoy the way things are done here: I love tile like this; it's consistent with the visual sense in Los Angeles."

GRANT MUDFORD, 1981

ROBERT DOISNEAU, 1981

To Robert Doisneau, who has lived in and around Paris since he was born in 1912, the city is "an eternal theater where the action never stops." The price of admission for Doisneau is "all the time I put in to catch the lucky moment. I walk, and to feel free, I must be alone. If someone were with me, I would be ashamed of the lack of organization and common sense in the circuits I make.

"I constantly change direction, come back on my own steps, hesitate. I follow people. And yet, I have to keep a distance in order to avoid stamping on their secret garden, otherwise the opportunity will be gone."

At the time Doisneau got his assignment to shoot the city, Paris was shrouded in rain clouds, and Doisneau was dismayed. But then he decided to turn the weather to his advantage, and use it to show how rain can act "as a mirror of the sky and reveal another aspect of man."

Believing firmly that a photographer "should never hesitate to waste time," Doisneau began his stroll in Ménilmontant, a working-class neighborhood, and went on to Saint Paul, a shopping area crammed with boutiques and markets.

Again and again he saw the beginnings of pictures about to form. Doisneau spent some time following a glass cutter carrying trays of his works on his shoulders precisely as such craftsmen have done for centuries, "but nothing came of it."

At last Doisneau found himself near the Louvre Museum as the rain clouds burst. "What luck! That sudden rain after hours of gray, dull, flat sky! People have an animal reaction: They panic, run, take shelter. Children laugh because they are soaked, and this all makes the image." Taking shelter himself under one of the museum's entrance gates, Doisneau realized to his delight that a composition was taking shape. He saw that a wing of the Louvre and the street lamps were forming a streamlined triangle. And down the very center of that composition, Doisneau noticed a family group running for cover toward him.

At such moments, when he knows that the image is there, Doisneau admits that "the nonchalant, phlegmatic man that I normally am becomes a *tiger!* I knew I must not miss it. When the children became funny with their penguin-like posture, then the button had to be pressed."

Before photographing the 14th Century castle of the Este family in Ferrara, Italy *(right),* Luigi Ghirri had already devoted hundreds of hours to exploring cities for several photographic projects: for a special invitational study of Paris, for a book about Rome, and for a survey of the cities in Italy's Po River valley. Even so, this assignment was a fresh challenge, because for Ghirri, in an Italian city "past and present are woven tightly together" into a riddle he never tires of trying to penetrate with his camera.

The task in shooting the city, Ghirri decided, was to portray "a web of tangled clues, the binding together of history, solid walls constructed from relationships, connections. Nobody sees a city simply as bricks and mortar. It's a layer cake, a history notebook compiled in strata."

To find a place where these complex ideas might be united in a single image Ghirri traveled to Ferrara, a Renaissance capital of commerce, learning and the arts. Although he had visited it before, Ghirri felt that there was in Ferrara still plenty for him to explore. As he walked about the old town, he says, "I became fascinated by the various large and small modifications that time had wrought upon the original plan. I realized that it was much more complex in structure, plan and spirit than I had realized."

One vista particularly appealed to him: It was the ancient castle of the Este family, a powerful family that ruled Ferrara for more than 300 years. Ghirri had admired the castle from a window in the home of a relative. "But," he says, "the light had not been so interesting then, and the ivy was thinner. This time it all came together, dominated by the great tower, and the light, too, was just right—very clear and bright, making sharp edges."

Here, Ghirri felt, was a simple view that formed the connection between the past and the present that he had been looking for, between "suspended time and present time, between the renaissance castle—an antique jewel—and the anonymous touch of today in the wall covered with growing ivy." □

LUIGI GHIRRI, 1981

Assignment: Love

*Your assignment is to make a photo-
graph that communicates love.*

It might appear that the photographers
who were given this instruction could not
respond as freely as those who dealt with
the mannequin or the city—for the topic
itself is a response. But as it turned out,
"love" as an assignment yielded a re-
markable variety of subjects that ranged
from relatives to animals.

Leonard Freed was overwhelmed at
first by the feeling that the assignment
evoked in him. "What potency this word
has!" he says. "It brings forth uncontrol-
lable, tremendous, untapped emotions
—both terrible and lovable." He decided
to find a vantage point from which he
could observe many kinds of love. From
experience he knew that a perfect "trap"
for all sorts of human situations was close
at hand—right in the elevator of his own
apartment building. One day, riding it up
and down dozens of times, he encoun-
tered old married couples, mothers with
young children, passionate young lovers.

The young couples stirred him most
strongly. But their self-involved quality
kept eluding him, even though he took
many photographs. Then he saw a solu-
tion. By including a third person along
with the embracing couple—a passen-
ger who was embarrassed and all too
eager to escape from the elevator—he
communicated the heat and heedless-
ness of youthful love.

When California photographer Lou Stoumen agreed to take the assignment his first impulse was to photograph couples in love. "Lovers it is," he reflected, and went to find some in a Santa Monica park. But nothing satisfied him. "I made some images," he recalled, "but nothing that said love."

Undaunted, Stoumen mulled over the project some more. "I'm a street photographer," he explained, describing the working technique he has used throughout his career, "and I go out in the street and I spend hours there. I'm like a fisherman. I go to a bend in a creek where I think there ought to be a big one."

On Stoumen's next trip into the street, which took him once again to a park, he encountered three people walking together. "I wasn't expecting a little group like that," he says. "They were sending out real vibes to each other, casual and easy, and having fun."

He did not like the setting in which he first spotted the threesome, so he followed, keeping his distance, because he felt that this was a situation in which his subjects had to be photographed unaware. Keeping the group in view, Stoumen took a shortcut to get ahead of them and focused on a crack in the sidewalk where he knew they would pass. "When they emerge from the trees," he thought, "I'll see what they look like."

As the picture at right shows, he chose a fortunate moment. He never learned who his subjects were, but the photograph he took clearly reveals the close bonds of affection between them. "The thing that struck me," admitted Stoumen, "was that each of the three had the same smile; their lips were parted in just the same way. Love is a great big wheel with many spokes, many kinds of good stuff. This is not the kind I went out after—but it's what I found."

LOU STOUMEN, 1981

The two women in these pictures, Margitte (shown at right in the top far-right frame) and Charlotte, are sisters, and photographer Starr Ockenga immediately thought of using them to illustrate the theme of love because of a closeness between the two she had noticed while making other pictures of them before this assignment. "To me, they had an alter-ego quality," said Ockenga. "There was almost a transfer of personality. Because they were so visually similar, I thought that might show in the pictures."

Ockenga photographed the sisters unclothed because, she explained, "I think there has to be an openness, a closeness in a relationship for two people to be able to pose nude together—and I wanted that to come through in the pictures. I also wanted to eliminate what their clothing looked like and deal just with the people so that there would be no color but the color of flesh."

To create this six-frame composite, the photographer first took three overlapping frames of the heads and then, standing slightly farther away, three overlapping frames of the bodies. Then she arranged them in two rows of three pictures each. "You focus on the face across the top," she says, "and on the body across the bottom. But I like the way the head sits on the body too."

When printing the pictures, Ockenga controlled the flesh colors carefully to match the skin tones of her subjects: "They're very round and pink, so I made them look that way."

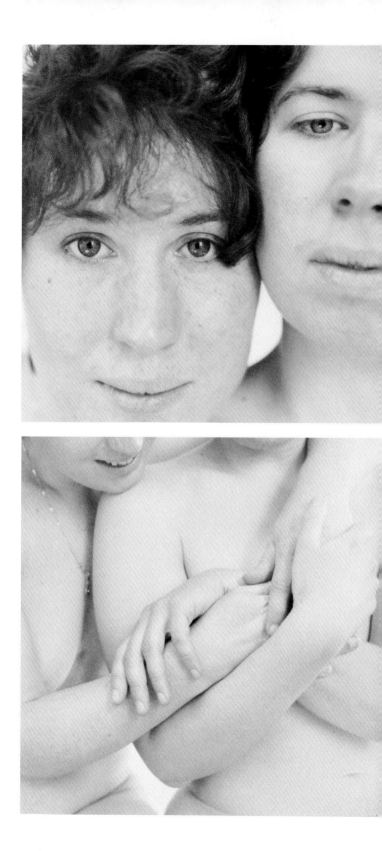

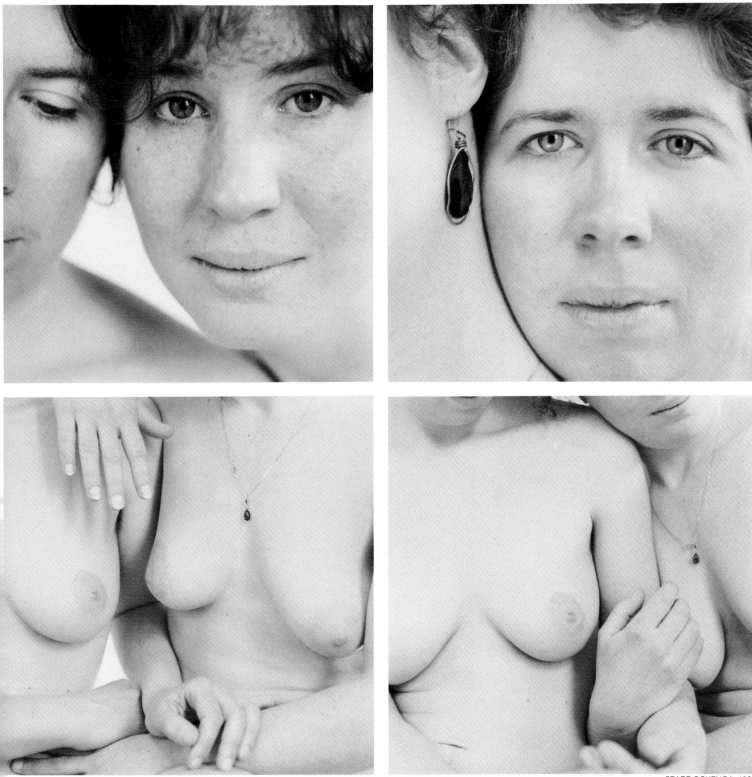

STARR OCKENGA, 1981

Peter Magubane knew whom he wanted to photograph for this assignment: a man he had heard about on the West Side of Manhattan who loved cats. The man and his cats were well known but locating him required some detective work. "The first day I just waited in the neighborhood for about five hours, and then I gave up.

"The next day I walked into each shop and finally came to a pet shop where the owner knew him and said he usually bought his cat food there. He told me to come back at 11 the next morning." Magubane did, and there at last he met schoolteacher Roland McGriff—and Sasha, Omar, Tiki, Sabrina, Magic Johnson, and Puff, aboard their specially contrived train of children's bicycles and wagons.

Magubane accompanied McGriff and his pets on their daily parade—which supplies exercise for the cats and entertainment for the neighborhood children. He took the picture reproduced here as the parade crossed a busy New York thoroughfare not far from Central Park. The shallow depth of field shows McGriff and the cats in sharp detail, but keeps the urban background from becoming too distracting.

"They all would walk around this way for about ten minutes," Magubane said, "and then they would stop for about 20 minutes. On a warm day, he never stops in the sun, always in the shade. And if it's too warm or too cold, he doesn't take them out at all. McGriff never permits people to feed the cats. He feeds them himself: He gives them ice cream, croissants—the sort of treats people would enjoy. In fact, he talks to them as he would to his own children."

McGriff obviously considers his menagerie an extension of his own family and lavishes on his cats parental care. Magubane emphasized this in his picture: The park-life background and the domestic grouping he chose suggest a family out for a stroll.

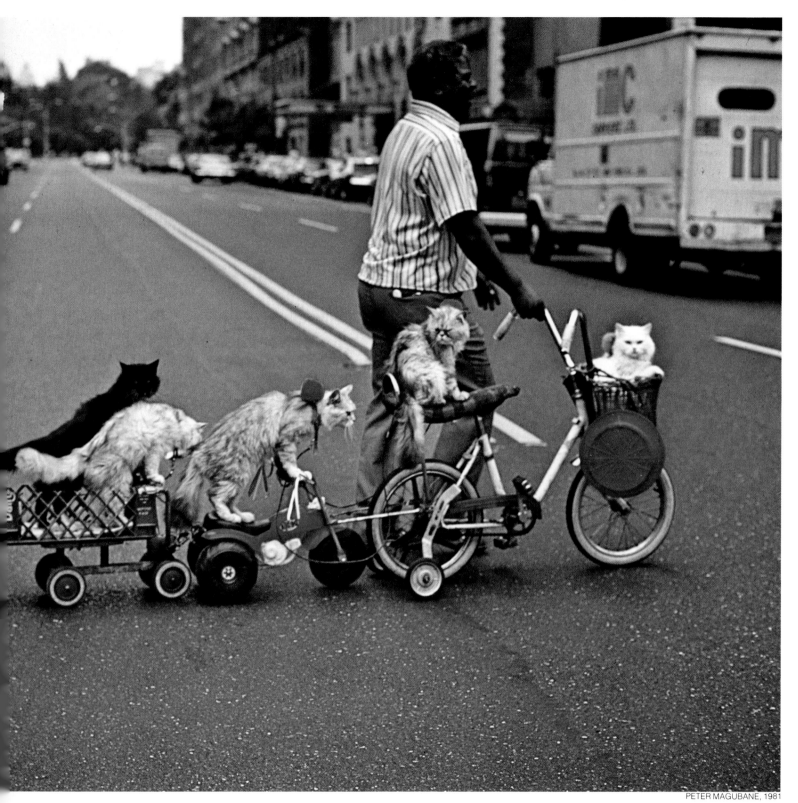

ALEX WEBB, 1981

"I think having a family is one of the great human experiences," says photographer Alex Webb, "and, not having one myself, I miss it." But Webb's search for family love, which led him to the living room of an apartment in upper Manhattan where he took the photograph at left, was not so much a sentimental journey as it was the result of some tough-minded analysis of the assignment.

"I thought about doing something with somebody who loved collecting things, but then that seemed almost like acquisitiveness, greed. I thought of doing something with a social worker, or someone who worked in a hospital, or a psychiatric center, but those smacked too much of professional care and not enough of true love." Then, as Webb was mulling over other possibilities—such as a picture of people greeting each other at an airport—an opportunity arose for him to photograph in the home of a family with a lively four-year-old boy.

"I thought it might be easier to find what I was looking for in a family with a young child—especially a Hispanic family," says Webb, who often worked in Caribbean countries. "I hoped that they would be demonstrative."

At the beginning, Webb recalls, "I was obviously an intruder. But I've worked in a lot of different situations, and I can get people to feel relaxed when I'm around. There are some places where you are never going to fit in, but here, after the initial giggles, the two people in the photograph, the boy and his uncle, began to open up and play with each other, and did not worry about me. They were pinching each other, and mimicking, and there was a funny tension. There was an aggressiveness about the kid, but it was a loving aggressiveness.

"I think a picture like this—about playful love—should not be too balanced. I wanted the figures a little to the left—I don't like pictures where everything is in the center. I liked the kid being up on the back of the couch."

DIANE ARBUS, 1971

Diane Arbus felt that love involves a "peculiar, unfathomable combination of understanding and misunderstanding," and she took a great many pictures in an effort to capture this quality. She went to a bridal fashion show and photographed girls trying on wedding dresses for their fiancés and mothers. She took pictures of a blind couple, a homosexual couple, and a pair of 67-year-old identical twin brothers who said they had never been separated a day in their lives. Then she found out about a New Jersey housewife who loved animals and was particularly devoted to a baby macaque monkey named Sam. Miss Arbus asked permission to photograph her at home, and the woman agreed.

The photographs were made with electronic flash—intentionally placed close to the camera to create a veiling reflection and harsh shadows. By simulating amateur snapshots, she hoped to catch a flavor of "total ordinariness." Most of the pictures did not satisfy her because the woman was "cooing or smiling or excited or eager or nervous." The one at left, however, had a quality that she found deeply touching. It has the startling effect of looking like any father's snapshot of his wife and youngster. And the effect is emphasized by the woman, who "seems extremely serious and grave, in the same way you're grave about the safety of a child." □

PAUL STRAND: *The Family, Luzzara, Italy,* 1953

The Importance of "When"

When people talk about time in connection with photography, they usually mean the time it takes to make a picture—its exposure time, determined by the shutter speed. Every picture involves time in that sense, of course, because the photographic image must be recorded on film over a certain period of time, however brief or extended. This chapter will consider time in another context: how a photograph can convey an idea of time to the beholder. The duration of exposure need not matter.

Photography explores the dimension of time from one extreme to the other —from the billionths of a second recorded by nuclear physicists studying evanescent atomic particles to the billions of years analyzed by astronomers tracing the birth of the universe in star pictures. It can answer many of the questions about time: When? How long? How frequently? (in some cases all in one picture). In the intermediate, more comprehensible ranges of time, which most pictures represent, photographers have found various ways of expressing time, partly for its own interest and partly because the sense of time influences the response of the beholder. Only three of these ways will be taken up here, and all relate mainly to the question "When?" First, the concept of suspended time: the picture in which the clock seems to have stopped. Its intent is not to specify an exact time, and its answer to "when" is ambiguous. Most landscapes, still lifes and formal portraits—pictures in which there is no indication of motion—are examples. Second, peak time: the so-called decisive-moment picture, which precisely specifies a particular instant and is as climactic and unrepeatable as the photo finish of a horse race. Third, random time: the picture of a before-or-after time, ambiguous again, like a sidelong glimpse of ordinary life—which indeed spends most of its time *between* high points.

Some other, less conventional ways of thinking about time are included in Chapter 5, and there are of course still other approaches—such as stroboscopic images and movement-blurred images, which can be made to answer the questions "How long?" and "How frequently?" The pictures that follow are widely disparate in subject and technique, as well as in the attitudes about time that they bespeak, and yet they have a common denominator. They are all reportorial in that they convey fact rather than fiction. What they show is not a creation of imagination but a view of the real world. Yet, in each, reality is employed to elicit a distinctive response from the viewer.

The effect produced by suspending time is eloquently demonstrated by Paul Strand's classic group portrait of an Italian family, reproduced on the preceding page. One hardly needs to be told that the group is gathered around the doorway to have its picture taken, or that it is a family and not an assortment of passersby. This is no brief encounter; the scene is carefully directed, the people painstakingly yet normally posed, at their impassive ease;

they obviously belong together. Strand later described the mother as "that pillar of serene strength," and the picture itself is full of self-sufficient serenity. It is a tableau, as artfully staged as the groups of marble-white living statuary that used to be unveiled with fanfare at the circus. And like those tableaux, it is symbolic, representing a concept that transcends the moment at which the picture was made. It is replete with emblematic details — facial resemblances, bare feet, work clothes, the utilitarian bicycle, the crumbling masonry — that reinforce the basic idea. Whatever this mother and her sons were doing before Strand gathered them for the portrait outside their home in Luzzara, Italy, and whatever they did when he let them go their ways, this family is captured forever to represent the unity of matriarchal families. While time stands still, these people share in a kind of immortality.

The fact that Strand used out-of-date equipment when he took the picture is, oddly enough, relevant to the suspended-time picture. When Strand spoke of the portrait, he recalled that "the photograph was made with a 5 x 7-inch Home Portrait Graflex, purchased in 1931, that was still of unimpaired usefulness to me. The lens, a Dagor 12-inch, was stopped down to f/32, probably." His exposure was presumably about 1/30 second. "The Family" could have been photographed in almost the same manner a century ago, had it existed then. In the early days of photography, most pictures were carefully posed in ways that suspended time simply because technical limitations made difficult any other scheme. It was possible — with skill and luck — to freeze a peak instant or a random moment, but such pictures did not become easy to make, and therefore attractive to experiment with, until the advent of fast films and small cameras in this century.

Today photographers can easily seek, or avoid, the arranged moment of suspended time, seek or avoid the decisive moment, seek or avoid the random, ordinary moment. Few restrict themselves to a single attitude toward time. The composed, static interval has its place, in everything from formal portraits to still lifes. The drama of the peak of action will always command attention. And offhand, fleeting glimpses increasingly feed the mainstream of modern photography. A photographer need not make an advance choice among the options for dealing with time; his conceptions and feelings about a subject can help him decide where it is to be placed in time. □

Suspended Animation

The great value of pictures that seem to suspend time is their ability to generalize. They can suggest ideas that characterize the whole experience of the human race. They specify no unique instant—if made earlier or later, they could look about the same. Yet they do not by any means ignore time.

Take the picture at the right: Like most photographs that suspend time it offers clear clues to time, and the first thing it says is that it was made at night, not in daylight. Also, as with most pictures in this section, one can make other generalizations from its contents. It is a street scene in a city—San Francisco, as it happens—and it is a modern city, as the truck proves. Yet it could be a street scene in any American city in the mid-20th Century. So it is emblematic—standing for dormant, actionless nighttime in all such places. Just before or just after it was made, the street might have been alive with activity, the truck might have moved, the light in the double doorway at right might have been switched off—except none of that matters.

Like the picture that opens this chapter and the ones on the next six pages, this one is specific enough about time to stand as an evocative symbol. All movement is banished; indeed all life is suspended—it is as if the clocks had suddenly stopped ticking and we seem to hear the silence.

Just as if he were working with a view camera, more often used for such meticulously arranged pictures as this, William Gedney mounted his handier 35mm camera on a tripod to frame with great care this nocturnal San Francisco scene. In it, time—and everything else—stands still. The time is significant to the photographer, who thinks that "streets take on a character at night, and there is a sort of primeval thing about darkness."

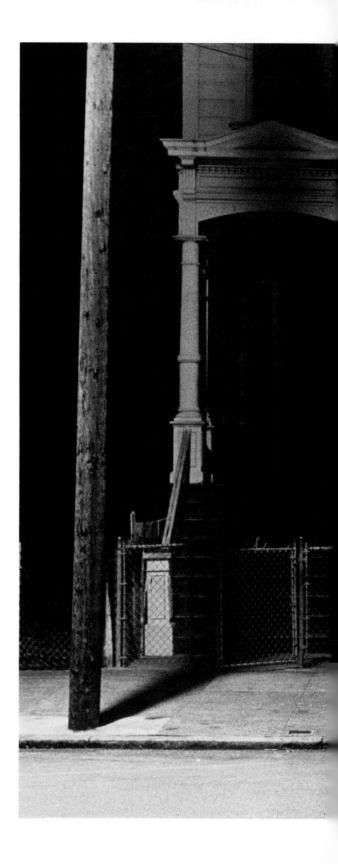

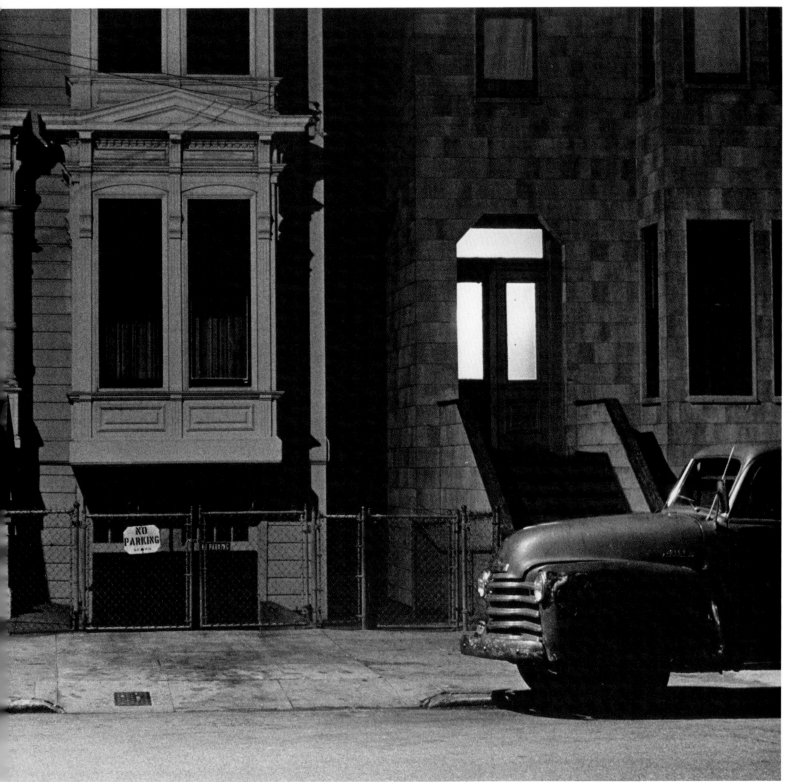

WILLIAM GEDNEY: *Street at Night, San Francisco,* 1967

In the lifelong project that the German photographer August Sander called Men of the 20th Century, this portrait of a Cologne laborer with a load of bricks was one among hundreds of precisely posed studies of Sander's countrymen. The time is both definite and ambiguous: The young man has paused between taking up his burden and laying it down, but there is no indication of hour, day — or even year. Holding his pose as if standing still for a portrait painter, the subject reveals his trade with dignity without becoming a stereotype. Asked why he worked as a Handlanger, or brick carrier, he replied: "There always has to be someone who carries stones."

In a friezelike tableau reminiscent of classical ▶ sculpture, a street repair crew is recorded in static positions that defy movement and time. The central figure's shovel is poised at its highest point, the patrolman has assumed a characteristic stance, and the man at far right signals his supervisory status as he stands casually scratching his arm. Thus held in time, the workers become an enduring symbol of their occupation — a significance heightened by the fact that their faces are either fully or partially obscured, cloaking them in anonymity.

AUGUST SANDER: *Laborer*, 1927

ROY DE CARAVA: *Asphalt Workers, Washington, D.C.*, 1976

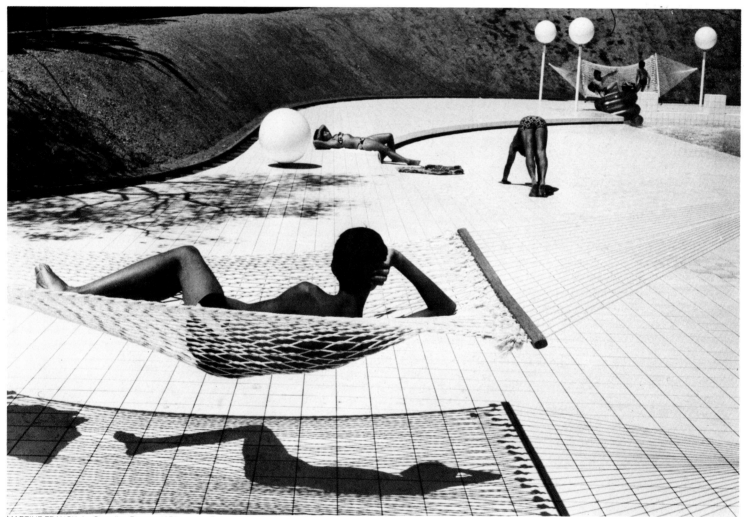

MARTINE FRANCK: *Le Castellet, France, 1976*

A sleek poolside terrace on a private estate in Southern France provided the setting for this elegant composition that balances the languid shapes of reclining figures with the unexpectedly arched form of a man doing push-ups. Although it looks staged, the picture was actually a quickly snapped candid, taken seconds after the young boy got into the hammock. "A few seconds later," Martine Franck recalls, "another boy climbed into the hammock. I changed angles but the picture was gone."

A relaxed and candid look at a mother and her ▶ child, this is one of a series of strong portraits made in New York City's East Harlem where photographer Bruce Davidson, according to one critic, captured "those private moments of suspended action" in the lives of his subjects. Much of the picture's impact comes from the unhurried confrontation between the camera and the subjects — and from the arresting contrast between the dark skin and light bedspread.

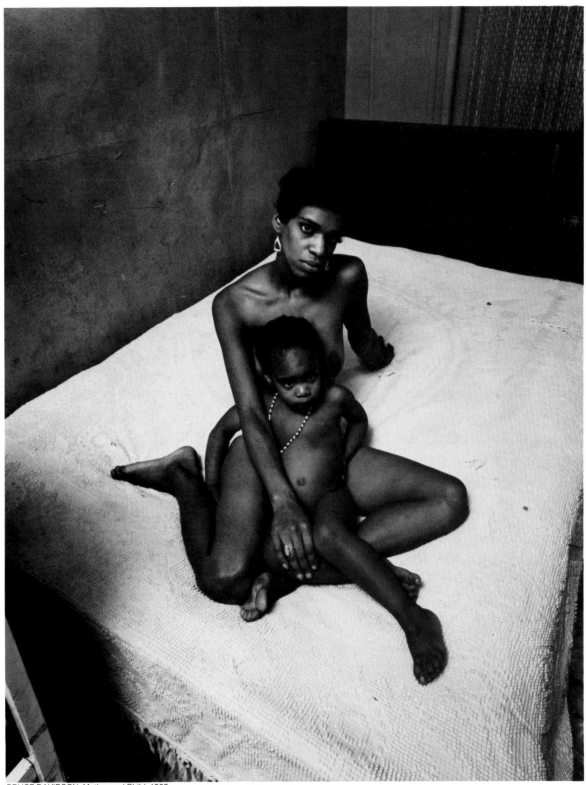

BRUCE DAVIDSON: *Mother and Child*, 1968

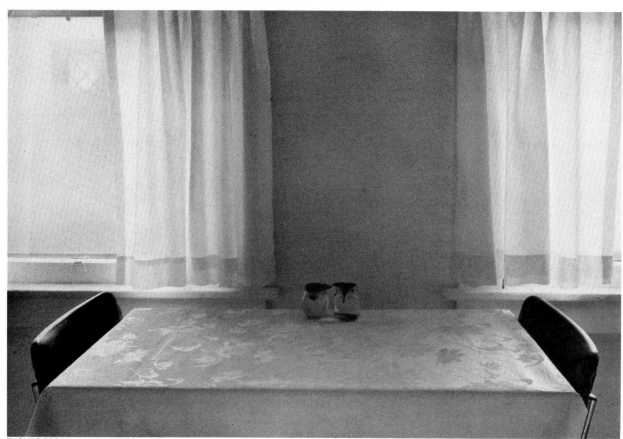

THOMAS BROWN: *Kitchen,* 1968

It was the muted quality of the light that first caught Thomas Brown's eye and led him to make this picture. In what he calls the "long moment" that the kitchen scene represents, everything is in static balance, at rest and with no hint of impending movement. It is between mealtimes —any meal, in almost any home of its kind.

After a spring rain, a deserted street in a suburban development near Portland, Oregon, was recorded with a view camera. Exploiting many of the qualities often found in landscape photographs— fine detail, subtle hues and careful composition—the photographer gives to this man-made scene something of the timeless serenity associated with natural views. Under still-roiling clouds, the drenched street winds through the clustered rooftops like a river between mountain peaks.

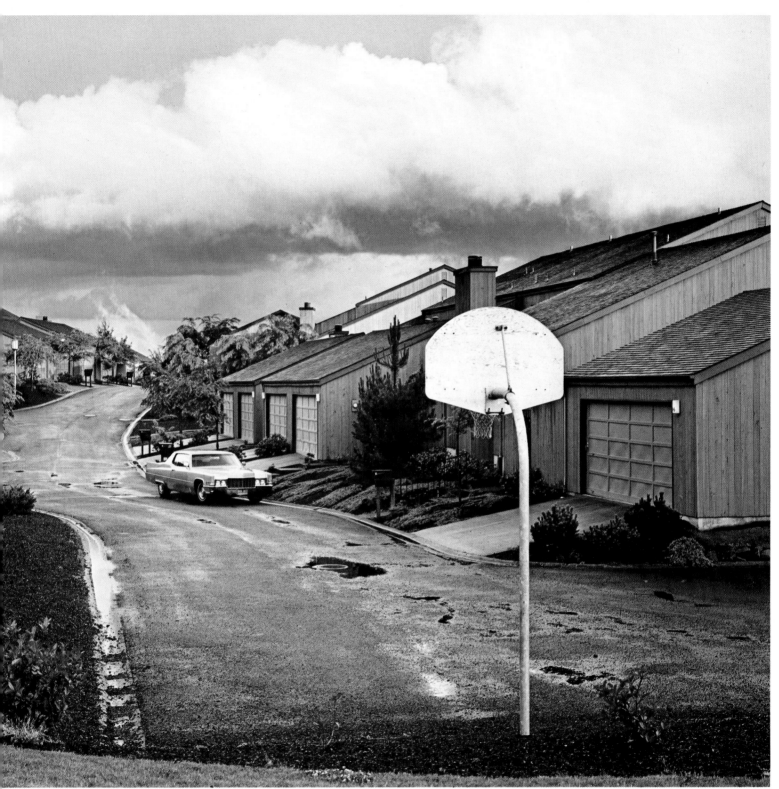

JOEL STERNFELD: *Lake Oswego*, 1979

The Decisive Moment

A quick and useful distinction can be made between the static pictures that precede this page and the dynamic ones that follow. In the picture that suggests suspended time, all action stops *for* the camera; in the photographs that sample time at either a peak or a random moment, the action is stopped *by* the camera. The action-stopping photographer who coined the term "decisive moment" to describe the picture that picks out a certain, rather than uncertain, moment in time is Henri Cartier-Bresson, and among the finest examples of this expression of time are pictures of his, such as the one on the opposite page.

The concept of the decisive moment depends on change. The photographer must think about what he hopes to record, then must shoot along and carefully watch the unfolding scene before him. He makes his picture when all of the visual and emotional elements come together to express the meaning of the scene. If he fails, he cannot try again because the telling moment will have eluded him.

Cartier-Bresson, as the author and art patron Lincoln Kirstein has written, "has been described as having a constant boxing match with time; time is both opponent and partner . . . to be punched and knocked down; one dances around an instant of time waiting for an opening, to fix, arrest, conquer."

Such arresting of time came with the development of photojournalism and the advent of the 35mm camera, which permitted pictures to be taken almost anywhere at almost any instant. While journalists used this approach principally in reporting news events, some photographers—among them Brassaï, André Kertész, Cartier-Bresson and Bill Brandt—soon sought to extract meanings and emotions from situations that involved not only newsmakers but ordinary people. Their results revealed how to capture for all time the fleeting moment that, more than any other, communicates an emotion or an idea.

Seizing an instant in flight, Henri Cartier-Bresson has caught the fugitive image of a man in mid-air. A moment later, when the man's foot hit the pavement, the picture would have been lost, for its beauty is locked into the transient symmetry of its composition. Many of the shapes are balanced against their reflections in the water. Even the leaping human figure is echoed by the image of a dancer silhouetted in the poster toward the rear.

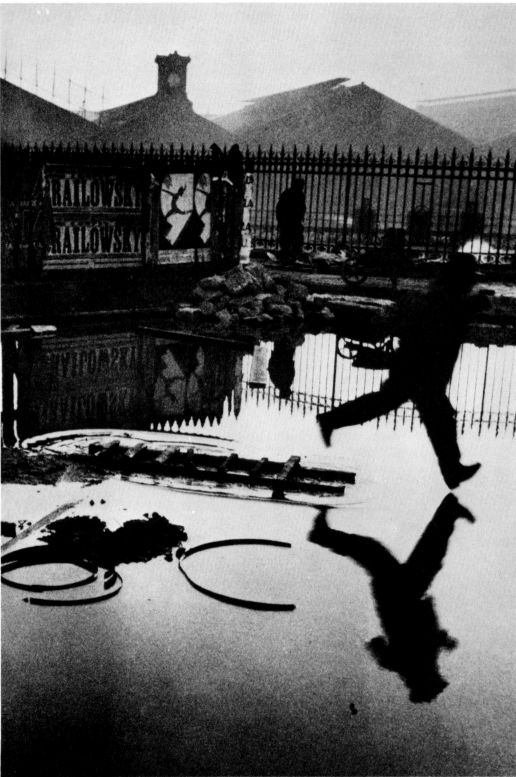

HENRI CARTIER-BRESSON: *Place de l'Europe, Paris,* 1932

MICHAEL SEMAK: *Italy, 1961*

Chance often provides the decisive moment, if the photographer can grasp it. Michael Semak stepped off a ferry at the resort island of Ischia, near Naples, and saw a pattern of umbrellas. With no time to focus or set exposure, "I raised my camera and pressed the shutter," he says. "The situation dissolved right after I got my shot."

Henri Cartier-Bresson interferes as little as possible with the changing scene in front of his lens. In this charmingly casual portrait of a Spanish woman in Córdoba, he allowed the subject to pose herself and caught her at the very moment that her hand unwittingly approximated the position of the hands in the corset poster.

HENRI CARTIER-BRESSON: *Spain,* 1933

ANDRÉ KERTÉSZ: *Touraine, France, 1930*

*Among the first to exploit the time-freezing
capability of the small camera was André Kertész.
He made this view in a French provincial town at
the moment when the human figures formed
a triangle, as the corners of the intersection do.
"The moment dictated what I did," he said later.*

In this glimpse of Italian seminary students kicking up their heels on the terrace of their college, Mario Giacomelli has caught the innocent joy of the young men expressed by the momentary arrangement of their bodies. "Photographing the dancing figures was the best way to capture the ingenuous, childlike quality of the priest's world," Giacomelli said. "Also, I liked the graphic composition of whirling shapes."

MARIO GIACOMELLI: *Seminarians Dancing,* 1965

MARY ELLEN MARK: *Wedding Day*, 1965

◀ *A London wedding gave Mary Ellen Mark a moment in which the figures of father, bride and onlookers arranged themselves into a design that heightened the interplay of emotions. She explains the scene as "three hopes coming together"—the father's, the daughter's, and all the dreams and fantasies of the children watching.*

An old woman, so hunchbacked she looks almost gnomelike, momentarily assumes a position that creates a revealing arrangement for Josef Koudelka's ready camera. Not only does her bony hand echo the hand-shaped knocker she is polishing but, during the split-second exposure, her back forms two patterns with the background: Its dark form creates a silhouette against the light-colored wall, and its curving shape contrasts with the strong vertical lines of the doors. "One always has to be open and ready for moments of accident and improvisation," says Koudelka. "They can create the richest experience of all."

JOSEF KOUDELKA: *Barcelona, Spain,* 1971

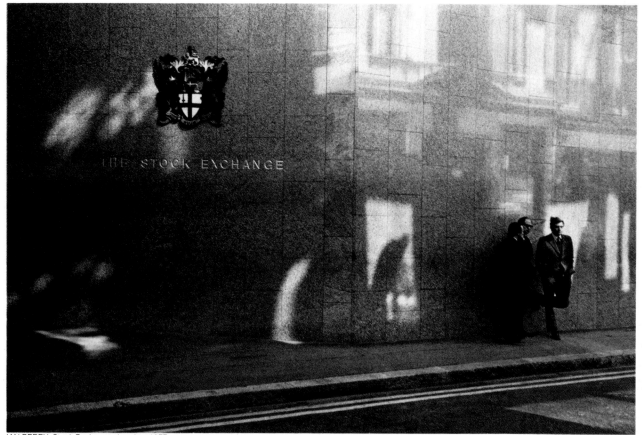

IAN BERRY: *Stock Exchange, London,* 1977

When the sun came out briefly in London's financial district, causing the polished granite walls of the stock exchange to mirror a nearby façade, Ian Berry saw a composition that contrasted one of the district's newest buildings with another of great age. His most pressing problem was a pedestrian rapidly approaching from the left. "I decided on one foot in the frame," he explained. "It gave the feeling I wanted and held it all together."

The light-and-dark balance of this scene "appealed to me," Jack Schrier explains, "and I had been waiting there for about ten minutes for something to happen. I could suddenly see two kids coming down the stairs. I knew it was going to be good and I got very excited. I waited until it was just right. Another fraction of a second and the kid at the right would have already been around the bend. A fraction of a second sooner and the head of the boy at the left would not have been separated from the black band at the top."

JACK SCHRIER: *Staircase at the French Pavilion, Expo '67, Montreal,* 1967

The Sidelong Glimpse

In the 1950s a group of reportorial photographers turned away from the precision of the decisive-moment picture. Rather than search out meanings from climactic, now-or-never moments, they switched their attention to another kind of awareness of time. They took to photographing those random moments when nothing much seems to be happening—life's non-events. Instead of the delicately poised compositions of Cartier-Bresson and his followers, their images often appear precariously off balance. Sometimes these photographers tilt the horizon line, cut off people's faces and feet with the picture frame, or they split their subjects in half with a stop sign or a tree trunk.

The results have a haphazard, seemingly unplanned look, as if glimpsed out of the corner of the photographer's eye. As often as not there is something jarring, even irritating, about such a photograph. Ambiguous and off balance, it disturbs the viewer—which is what the photographer intended.

This elusive, glimpsed quality in photography first caught the public eye in 1959, with the appearance of Robert Frank's book *The Americans*. A collection of seemingly chance glances at life in the United States—like the bar scene on the opposite page—Frank's book established a new concept of the right moment to take a picture. The "decisive moment," to him and the other new realists, does not fairly represent the real world. The perfect patterns that merge at such a peak moment, they believe, are not a normal part of seeing. And to try to contain those patterns in a photograph is to deprive a picture of its honesty. "I don't want that in photography," Frank contends. "The world moves very rapidly, and not necessarily in perfect images."

By tilting his camera and shooting from the hip, Robert Frank made this quick glimpse of cowboys at a bar. The picture seems to slide off the page like a falling shot-glass. It suggests not only the pungent odors of whiskey and cigarette smoke, but also some of the upset balance of contemporary American life. Indecisive, offhand, the picture reveals a moment of raw reality.

ROBERT FRANK: *Bar — Gallup, New Mexico*, 1955

GARRY WINOGRAND: *Taxicab, London,* 1969

The sidelong glimpse often immobilizes a scene at the instant before, or after, its various elements fall into place. If the photographer had waited a bit longer before taking this exposure of a couple leaving a taxicab, the man's face might have emerged from behind the car door, the woman might have dropped her right hand. And the sense of immediacy would have been lost. As it is, their movements seem unsynchronized, their positions awry, their next actions for the viewer to guess.

LEE FRIEDLANDER: *Revolving Doors,* 1963

Like most pictures in which time is caught askew, this photograph raises questions it refuses to answer. Who are the people? What are they doing there? Why is one man's face cut off, while another man looks right at the camera? But that was Lee Friedlander's purpose—to puzzle the viewer, just as everyday scenes often do.

MARK COHEN: *Wilkes-Barre, Pennsylvania*, 1973

It was a strand of hair straying across the neck of this young girl that first caught Mark Cohen's eye and led to this unusual close-up. Once his attention was arrested, Cohen worked quickly to capture the detail that fascinated him. "I jumped up real close to the girl," he recalled, "about a foot away," and used an electronic flash unit to freeze the instant. The resulting image, with its oddly foreshortened view recaptures the immediacy and randomness of the passing detail that originally caught his eye.

ROBERT FRANK: *Bar—New York City*, 1955

*A glance inside a New York bar, another
photograph from The Americans, has a feeling of
drabness and melancholy. The garish lighting and
the vanishing figure at right add to the sense that
this is a sad café; the people are not relating
to one another at all. Novelist Jack Kerouac wrote in
the book's introduction that after seeing pictures
like this "you end up finally not knowing any
more whether a jukebox is sadder than a coffin."*

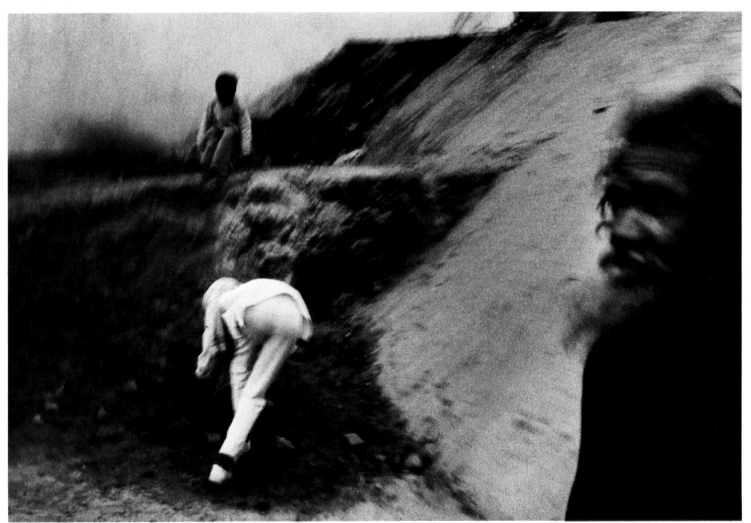

ANTONIN KRATOCHVIL: *Benares, India,* 1978

Strolling along the embankment of the River Ganges at twilight, Antonin Kratochvil was passing two boys tossing rocks at each other when he caught a glimpse of an old man approaching him from behind. To preserve the shadowy, mysterious, not-yet-fully-focused impression of the actual incident, he snapped the scene without pausing to raise the viewfinder to his eye; the picture retains a quality of being seen out of the corner of the eye.

NAZIF TOPCUOGLU: *Wells Street El Station, Chicago,* 1981

In this jarring glimpse of an elevated train station, a random moment in a public place was not so much recorded as transformed to emphasize its anonymous, transitory nature. Topcuoglu rotated his camera during a half-second exposure to create the enigmatic light paths. At the same time he fired a gelatin-covered flash that not only recorded waiting passengers in sharp detail but also gave them an unreal, radiant hue.

Challenging the Traditions

GEORGE CURTIS BLAKELY II: *Seashells,* 1981

Innovation is the rejuvenator of art. Without a steady flow of new methods and fresh ideas, any field, whether it be photography or the writing of movie scripts, begins to go stale. A good innovator, of course, should be thoroughly versed in the fundamentals of his craft. But in challenging old standards and exploring new approaches, he may help the art retain its vitality. This has been true in photography from the first and it is still true today, as resourceful and imaginative photographers continue to experiment with new ways to express themselves in pictures.

Many photographic innovations seem baffling at first because they take people by surprise. In breaking free of conventional molds, they ignore our preconceptions, and confound our sense of what to expect. In looking at most photographs, most people share a set of basic experiences and ideas about photography that enables them to recognize what they see. The need for this shared understanding is illustrated by anthropologists' experience with people who have had little or no contact with modern technology. When scientists visit a remote area, they sometimes try to befriend their hosts by taking their pictures with instant-developing film, and offering them the finished print. But if they have never seen photographs before, they are likely to hand back the print with blank, uncomprehending looks. Nothing in their experience has given them the ability to interpret tones or colors on a piece of paper—a photograph—and recognize in it their own likenesses. In the same way, though on a much more sophisticated level, some of today's photographic innovations go so far beyond our experience of what a photograph is about that we simply do not know, at first, how to react to them.

The pictures in this chapter are the work of innovators and many of them, on short acquaintance at least, are baffling. Their creators have used the materials of photography—but have utilized them in a variety of puzzling, unconventional ways to express their own special visions.

For example, the striking abstract design on the preceding page started with an ordinary picture postcard—a photograph of seashells. The photographer bought 200 copies of the card, and taped them together in a swirling pattern. The circular design and the lines rising to one side suggest the rolling of waves on the seashore.

The creation of such experiments is a recurring "new wave" in the art of photography. Every decade or so, photographers such as Moholy-Nagy and Man Ray turn up with abstract work that challenges the conventions all over again. The latest such challenge to the traditional photograph began in the early 1940s, at the same time some painters were beginning to explore abstract expressionism, a style that also maintained that art could be expressive without being representational. The photographer who opened the way was Aaron Siskind, a close friend of abstract expressionists Willem de Kooning and

AARON SISKIND: *Rome Hieroglyph 8,* 1963

*Fading graffiti left on an exterior wall in Rome
—undecipherable, undated markings by
anonymous men—provide the sources for shapes
and textures that make up this picture. But
the real subject is the way in which the markings
reveal the photographer's own feelings and
reactions. "As the language . . . of photography
has been extended," Aaron Siskind wrote,
"the emphasis of meaning has shifted—from
what the world looks like to what we feel about
the world and what we want the world to mean."*

Franz Kline, with whom he once shared space in a New York gallery exhibit.

Siskind's early work, done in the 1930s, was generally in the documentary style: He made photographic reports of Harlem tenements, Bowery life and New England architecture. His emphasis then was on subject matter. But somehow Siskind felt unsatisfied. "There was in me the desire to see the world clean and fresh and alive," he says, "as primitive things are clean and fresh and alive. The so-called documentary picture left me wanting something."

And so in 1943 he turned his camera on some of the world's least fresh but most primal objects—rocks and boulders that he found along the New England seacoast. He photographed them and the spaces surrounding them as starkly elemental shapes that bore a certain family resemblance to some of the work of the abstract expressionist painters. The emphasis was no longer on subject matter. The pictures were not just reports of rocks, but expressions of something far more personal and subjective—Siskind's own thoughts and reactions to them: "I began to feel reality was something that existed only in our minds and feelings."

There is a decidedly nonrepresentational quality in most of Siskind's later work. His picture on the opposite page shows a peeling wall in Rome, but it is scarcely recognizable as such. For the viewer is meant to go beyond the original subject and involve himself in the photographer's treatment of it, in the textures and shapes that express the photographer's personal reaction.

Today many innovative photographers do not hesitate to make up their own scenes, using ingenious assortments of picture-taking and darkroom techniques. They combine several pictures into one, or break up a single view into parts; they daub their photographs with paint; they construct whole scenes just to photograph them, and they use office copying machines instead of cameras to create striking images from bits of torn paper, flowers, fabrics and light itself. In short they try to draw upon all areas of human experience to suit their own purposes. And in each case in which the photographer has succeeded, innovation once again has expanded the art. □

One Picture from Many

The boundaries of photography are increasingly being expanded by innovative works that transcend the conventional definitions of the photograph.

What does constitute a photograph? The definitions generally specify a two-dimensional picture of an actual object or event, a depiction of something that has happened at a certain time and place. Within these bounds, photography has demonstrated both its power and its limitations. The power is in its gripping illusion of reality, whether quiet or dramatic. The limits appear when the viewer realizes he is seeing, on a single flat surface, only selected portions of a scene out of which the photographer must create a sense of the whole event.

Feeling constrained by these restrictions, some photographers have set out to break them—or at least bend them. While continuing to employ photographic methods, they have questioned many of the traditional assumptions: Does a photograph always have to be flat? Does it have to be limited to one image in a single frame? Must the event photographed consist of one event, or can there be several? Does this event have to be one that anybody could witness—or is there not a place for photographs of "events" that have happened in the mind's eye or in a compelling dream?

To each of these questions the answer of these innovators has been "No." They have shown that several images can be juxtaposed to form one picture, and that it may say more than any one image could. The results are varied and all of them challenge the viewer's preconceptions: a photograph within a photograph *(pages 152-153);* a contact sheet that serves as the single portrait of a room *(pages 154-155);* a composite that combines the subject's portrait with scattered bits of writing taken from his books and papers *(page 158).*

They are photographs, and yet they are also more than photographs—each a unique way to convey the artist's intent. The reward for the beholder, in recognizing the innovations these pictures introduce, is to enlarge his own concept of photography's outer limits.

This composite of 20 prints conveys the idea of people streaming along a city street better than any single image could. The people glimpsed here, though present in the street at different times, are given relationships one to another by being made to appear, disappear and sometimes reappear. To make the composite, the photographer stationed himself on a sidewalk in Philadelphia and took pictures of passing pedestrians. He selected 10 negatives, several of which he printed more than once, juxtaposed the prints to create a variety of light-and-shadow impressions, and played with a variety of human postures to link one print to the next.

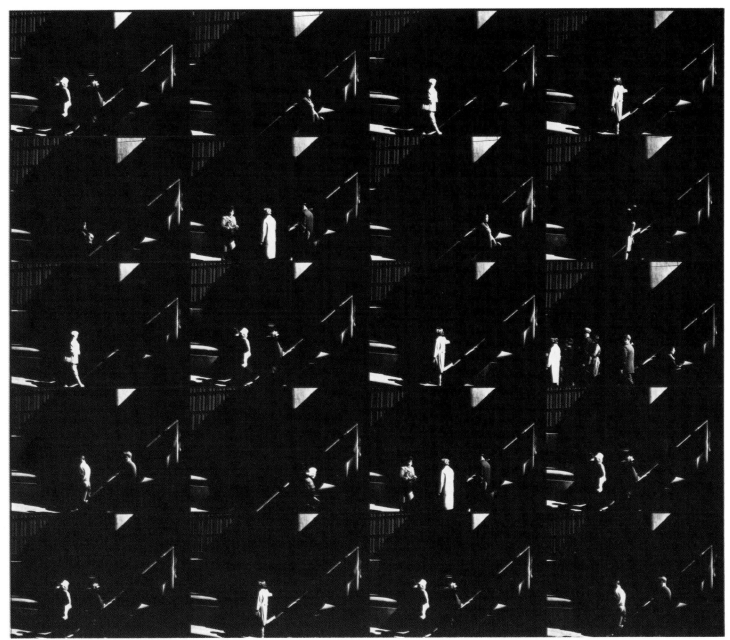

RAY K. METZKER: *Juniper Street*, 1966-1967

KEN JOSEPHSON: *Postcard Visit, Stockholm, Sweden, 1967*

The photograph of a Swedish castle (above), with a hand cryptically holding up a picture postcard of the same castle, gives a dual view of the same scene: the larger one in winter, the postcard scene in summer with the trees in leaf and the statuary unsheltered. Thus two events, in two seasons, are represented in one frame—and the viewer is reminded that both castle and postcard are only pictorial representations.

Two photographs of the same rocky landscape, ▶
a larger background photograph in black and white and a smaller color photograph, were superimposed. The photographer used acrylic paints to blend the two pictures and extend the landscape beyond the conventional photographic borders, reminding the viewer that in space, as in time, every photograph is a selection from a much more extensive scene.

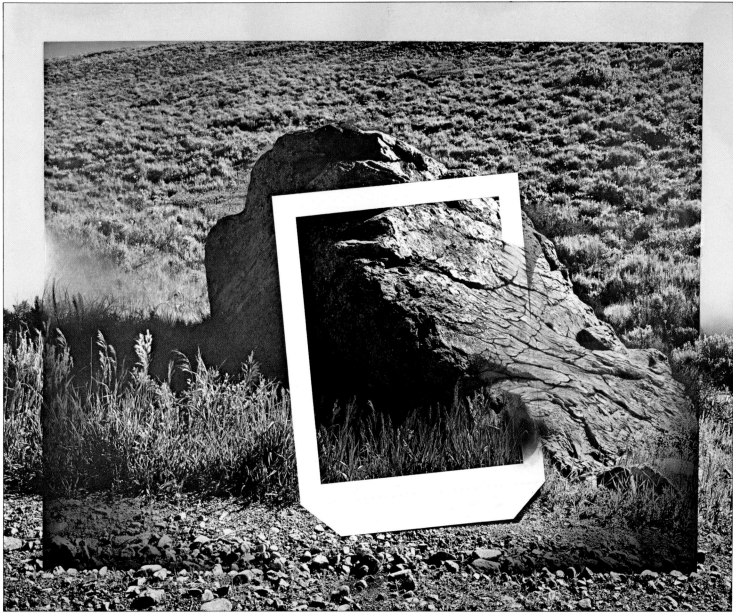

EVON STREETMAN: *Idaho Fantasy*, 1980

This photographic mosaic is a conventional contact sheet of numbered frames arranged in an unconventional way. In the usual contact sheet, the viewer examines each frame as an individual picture. Here the entire sheet is the photograph: a representation of a room that contains a bicycle, a wicker sofa and a chair. To make it, the photographer shot each area of the room in sequence. When the viewer scans the sheet, a "consecutive" impression of the room and its contents emerges, challenging the conventional notion that a photograph of a single subject can be accomplished only in one frame.

REED ESTABROOK: *118 North Main Street, Providence, Rhode Island*, 1969

To create this impossible image of a woman with nine breasts, the photographer first took hundreds of close-ups with a hand-held 35mm camera. He printed the pictures on contact sheets and then selected and cut out 336 tiny prints, which he attached to a backing to make a final image measuring 21 x 24 inches. The photographer feels that, although tedious, the process is rewarding: *"I find it pleasurable,"* he says, *"and in some ways almost meditative."*

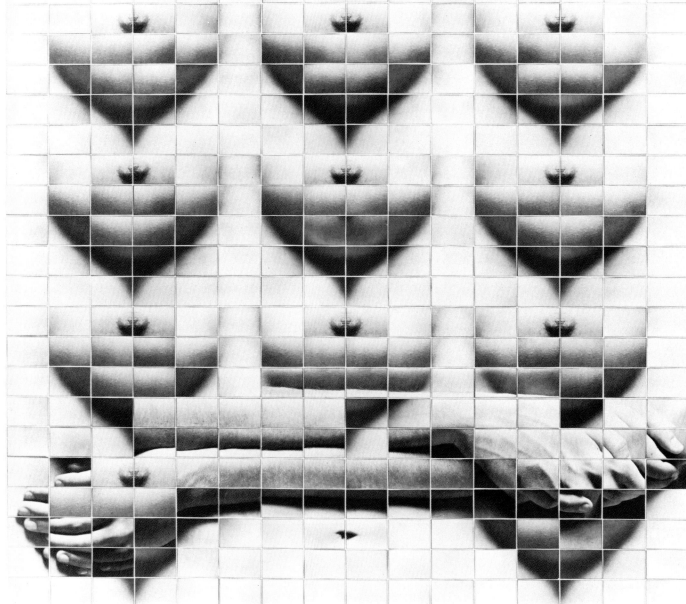

TETSU OKUHARA: *Woman with Crossed Arms,* 1973

PATRICK NAGATANI: *Chartres, France,* 1980

*Using Polaroid SX-70 color film, the
photographer took nine views of a cathedral, three
with his own hand holding a color card. He
rephotographed and printed each image, then hand-
colored them to form this composite.*

This composite portrait, a tribute to the photographer's dead father, was created in an unusual way. A photographic portrait and slides of writings representing the thoughts of both father and daughter were projected onto pages of work records or religious texts that were important to the subject, and photographed on black-and-white film. Twenty-five of the images were arranged to form this portrait. The result is an attempt to reveal the contours of the subject's mind as well as those of his face.

ESTHER PARADA: *Memory Warp II*, 1980

To make this picture — one of a series of partial double exposures of mathematical symbols on blackboards — the photographer did not fully advance his film after each click of the shutter. After making contact prints of the images, he cut the prints into strips, arranged the strips in a sequence and rephotographed them. The bold, calligraphic quality of these symbols especially appealed to the photographer: They were written on a university blackboard by a blind mathematician.

PAUL BERGER: *62*, 1977

Into the Third Dimension

Although most photographers find their subject matter existing in the real world, others create worlds of their own to photograph. They prefer to arrange objects on a table top, pose models in a studio or construct things especially to be photographed. These techniques have most frequently been exploited for advertising and fashion photographs. But a growing number of individualists are borrowing advertising techniques to create outlandish pictures, many of them unsettling and some hoky, that have no resemblance to advertisements.

These created photographs may be as bereft of literal meaning as Dadaist wallpaper — or overflowing with arcane visual puns and jokes. But all are linked by their makers' desire to find a visual form for their own ideas.

The new mode has affinities with sculpture, since three-dimensional models are used. It also looks back to a 19th Century tradition of staging elaborate tableaux for the camera, such as those arranged by Victorian photographer Julia Margaret Cameron to illustrate popular stories. But there is a difference. The 19th Century photographers hoped that their fake recreations would be taken for real. But the photographers who specialize in created pictures today do not try to deceive. Their pictures are not fake anything, they are genuine fiction.

Glowing cylinders of paper and light were made by the photograper especially for the picture at right, providing both subject and illumination. He wrapped sheets of white photographic background paper around two fluorescent light tubes, then put strips of colored paper in each cylinder; the right cylinder was torn and split to allow more light to get through.

DAVID HAXTON: *Colored Strips in Cylinder and Torn Cylinder*, 1979

JERRY McMILLAN: *Texas*, 1978

◀ *This picture of a paper cutout of the state of Texas exploits photography's ability to create, in two dimensions, an illusion of three. Paper was cut to the outline of the state; when folded and crumpled, it resembled imaginary mountains and valleys. Then it was photographed in such strong sidelighting that the viewer can almost feel the rise and fall of ridges and hollows of a three-dimensional map.*

The odd-looking object at right, which could be anything from a modernistic birdhouse to a model for a science-fiction robot, was made by cutting slightly irregular crosses on four sides of a cardboard shipping container, then folding each cutout into a small box suspended at the corner of the carton. The box and its four small satellites were mounted on studio jacks that photographers use to position still lifes, and shot with Polaroid's 200-pound, 20-by-24-inch color camera.

ROBERT CUMMINGS: *Four Cubes from One,* 1980

TOM DRAHOS: *Memories of Egypt,* 1979

*Hieroglyphics inscribed in an Egyptian bas-relief
and a modern cassette from a tape recorder were
combined in this photograph to symbolize man's
desire to convey his thoughts. The Czech-born
photographer made a transparency of the
sculpture in the Louvre. Then he projected the
transparency on a screen in his studio, added
the cassette and rephotographed the arrangement
on black-and-white film.*

To create this eerie fantasy of life after an atomic holocaust, the photographer painted a real room ash-gray and used an elderly couple who were her neighbors as models. However, the 25 cats were constructed from chicken wire and plaster and painted an acid green. The combination of real and fabricated objects gives the picture the disturbing quality of a nightmare come true.

SANDY SKOGLUND: *Radioactive Cats*, 1980

Masterworks from a Copy Machine

An office copying machine, meant for duplicating letters and documents, is not most people's idea of a likely source of art. But a number of inventive photographers have turned it into a picturemaking instrument. The office copier is a kind of camera, containing light-sensitive material and a lens, but it is a camera that cannot be taken to a subject; the subject must be brought to it. Usually, the picture is made by placing the subject on the copy machine's document glass.

Because modern office machines are designed to make quick copies, there is no way to control focus or alter aperture setting. Depth of field is severely limited, providing sharp focus only for objects placed directly on the document glass or within an inch above it. Copy artists, however, capitalize on this restriction, using the limited depth of field to transform subjects in unusual ways *(page 168).*

Although a few photographers still use the black-and-white machines, most prefer the color machine. Both machines utilize a process that creates a positive image directly and instantly by means of powdered-ink toners, not the silver compounds used in ordinary photography. The toners are transferred onto paper by a charge of electricity.

In color copy art, the photographer is able to adjust the balance and intensity of the color, and can use almost any kind of paper—including high-quality rag paper—for reproductions. Within limits, the color changes are predictable, but variations in the amount of the powdered-ink toners often yield surprising results.

Copy-machine artists have developed many different techniques. Some create abstract designs by shining light back into the copier's document glass *(opposite, right)*. Others duplicate their own hands, faces or other three-dimensional objects *(pages 169 and 172)*. Still others combine single prints to make a larger picture. Whatever the technique used, however, chance and skill are unnervingly intertwined in this serendipitous art.

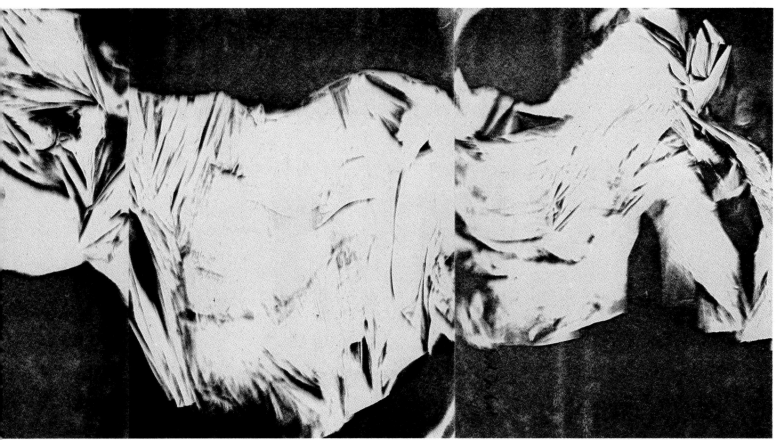

ESTA NESBITT: *From the Transcapsa Series*, 1971

The liquid, glowing shapes of this abstraction were made by moving a sheet of reflective plastic across the window of a black-and-white copier while it was printing. Light from the copier's moving light bar, which provides illumination for exposure, was reflected back into the machine lens by the plastic, recording a continuous pattern of light. The hand at the bottom of the picture belongs to the artist.

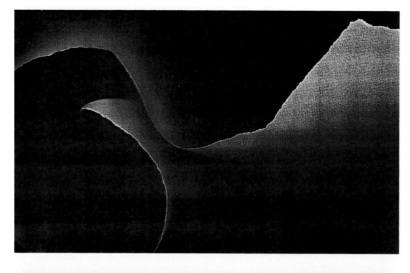

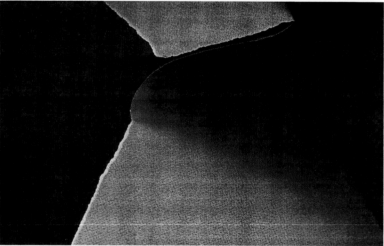

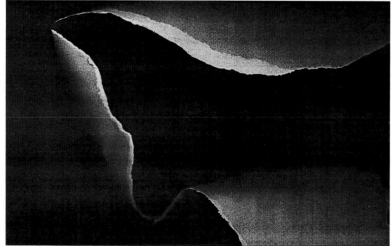

The mysterious empty spaces in these three images, which reflect feelings the photographer had as a child about nighttime darkness, were obtained by tearing and folding pieces of heavy paper into shapes and propping them on the copier document glass. Because of the machine's limited depth of field, only surfaces within an inch of the glass were reproduced, leaving the spaces beyond them almost black.

JUDITH CHRISTENSEN: *From Night Edges Series,* 1979

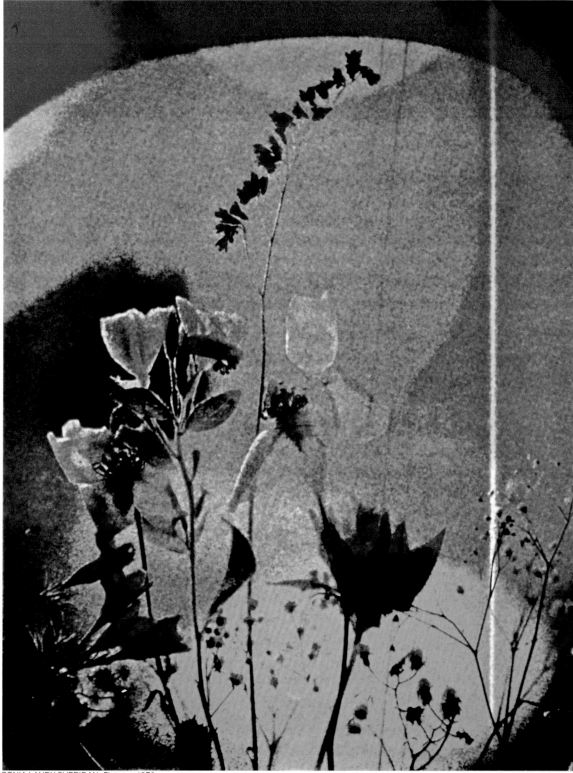

SONIA LANDY SHERIDAN: *Flowers*, 1976

Iridescent colors, produced by shining fluorescent and tungsten lights into the copier while the lid was open, light up the background of a print by a photographer who pioneered the use of the machines. The type she worked with, an old one that employs oil-based dyes instead of powdered-ink toners, is preferred by many because it yields rich, luxurious colors.

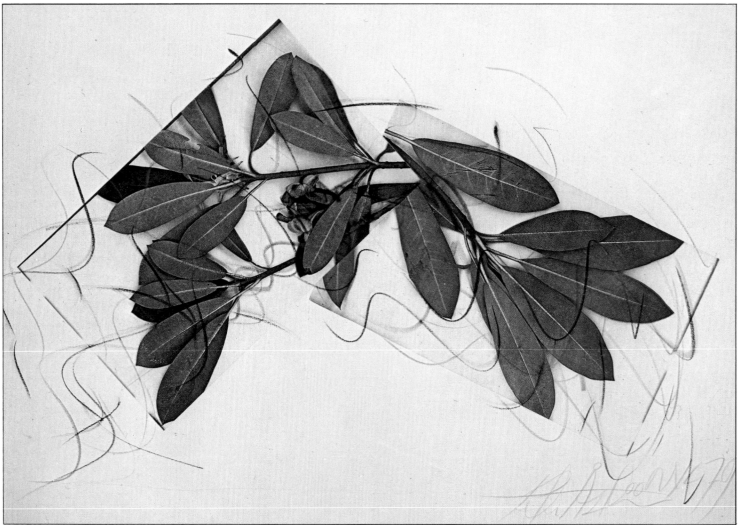

PETER ASTROM: *Bent Flowers*, 1979

*Two separate color copies of real magnolia
leaves—one including irises—were combined for the
still life above. Both copies were transferred in
a heat press to a sheet of rag paper. Then the artist
added a network of colored crayon lines.*

JOAN LYONS: *Untitled: Xerox Drawing,* 1978

For this composite image, the photographer used a black-and-white copy machine from the late 1950s. It has a movable camera mounted on a flat bed that is rolled back and forth on runners. The photographer placed a ground-glass screen in the camera back to focus the picture, then inserted an electrostatic plate to make the exposure. In transferring the image of flowers and leaves to drawing paper, she turned it four different ways to achieve the symmetrical pattern. Finally, she worked over the image with pencil and colored chalk to unify the elements.

An unusually complex application of copy techniques creates a dreamlike vision of femininity. A photograph of the photographer's nude body was combined with separately copied images of her hands, a negligee and a curling iron. The elements were then transferred onto real fabric and superimposed to make the final image.

SUDA HOUSE: *What's a Woman to Do?*, 1979

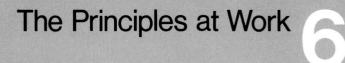

ANDRÉ KERTÉSZ: *Satiric Dancer*, 1926

In Pursuit of Excellence

Over the altar of a church in Venice hangs a Renaissance painting that is clearly a masterpiece. For 100 lire (less than the price of a package of cigarettes), a tourist could put on earphones and listen as the recorded voice of an art critic explaining the significance of the work announced, "This is the greatest painting in the world." Such a reckless statement might have led the knowledgeable tourist to ask for his 100 lire back. And yet, despite the fact that works of art cannot be ranked on any absolute and universally acceptable scale, like diamonds or eggs, judgments of artistic merit are continually being made.

The photographer, whenever he looks through his viewfinder or examines his negatives in the darkroom, must choose one picture out of all the possibilities; he must be able to decide which exposures are better than others — and understand, intuitively or logically, why. If he cannot employ principles of photography to recognize excellence, he can never make a good photograph — except by luck.

This book has approached the difficult question of gauging success in photography by exploring the principal options involved in creating a picture. Every object to be photographed can be analyzed for a number of characteristics. It may exhibit one or more of the basic components of vision — such as shape, texture, form and color — and the components can be arranged within the picture frame to generate visual interactions that suggest such qualities as balance, rhythm, proportion, dominance and subordination. In the humorous photograph of a Parisian café dancer on the preceding page, for example, André Kertész employed the contrasts between dark and light to make an abstract design at the same time that they focus attention on the dancer and the pieces of sculpture that flank her. The witty parallels between the dancer's pose and the sculpture were also deliberately set up to create a sense of fun, satirizing the exaggerated shapes and gestures of the statues, for arrangements of visual elements can be (and generally are) manipulated to show a certain response on the part of the photographer — that is, his interpretation of the meaning of the subject.

The photographer also may indicate his intent through his representation of a sense of time — a cleverly seized instant of action, for example, or a randomly chosen moment — or he may achieve his purpose by his basic approach to photography, choosing either the orthodox idea of photographs as small, flat objects that depict reality by recording light on film, or some newer scheme such as scratching on raw film, a process that does not depend on light and disregards reality.

All these considerations are analogous to a map of photographic possibilities. The photographer who is aware of the regions described by this map is much more likely to reach his goal of excellence than the one who proceeds

blindly into the unknown. The map can indicate a useful way to a destination, even though it cannot set an exact course.

The history of photography is full of attempts to specify more precisely the best course for making pictures. Two of the most prominent schools of thought have been the so-called pictorialist and purist approaches. The pictorialists, who exerted a good deal of influence during the 19th Century, held fixed opinions about what a photograph should show and how it should be shown. They shared the artistic concepts of painters of their time, and they could be downright vehement in insisting on their tenets; for example, in 1859, Francis Frith, a leading English landscape photographer, advised a beginner that "if he be possessed of a grain of sense or perception, [he] will never rest until he has acquainted himself with the rules that are applied to art . . . and he will make it his constant and most anxious study how he can apply these rules to his own pursuit." The pictorialists believed photographs should have a dramatic center of interest and should be as tasteful as paintings and prints of the time, leading the viewer's eye through the image in a lively manner, but all the same giving a comfortable feeling of stability. They also had strong opinions about the ideas to be conveyed, preferring mythological themes, sentimental visions of family life, idyllic landscapes and other subject matter far removed from everyday reality. And their technical procedures—employing soft-focus lenses, hand-manipulated prints and many other techniques—made their images unlike those of normal vision but much like those in paintings.

The purists, reacting to the excesses of the pictorialists, adopted a completely different set of canons. They insisted that a photograph show what human vision would see under technically ideal conditions: everything perfectly sharp and clearly positioned in space (humans do not normally see that way, of course, any more than they normally see the fuzzy, sweet visions of the pictorialists). Techniques that brought such results influenced content and interpretations; the purists' portfolios are full of sweeping landscapes that delineate every texture and tone, and calm portraits that reveal each pore in the subjects' faces.

Both the pictorialist and purist approaches yielded great pictures. Their systems of photography worked, because gifted creators were able to meld visual ingredients, meaning and design into intelligible, concerted wholes—regardless of which set of rules the photographer chose to work with. The portfolio of pictures on the following pages presents an array of routes charted across the map of options. Here is the art of photography, as practiced in the 20th Century, working its spell of communication in a variety of ways. Perhaps the creative thrust behind each picture can only be described by the mysterious term *genius*—but the fundamental principles exhibited by the pictures are both explainable and universally available. □

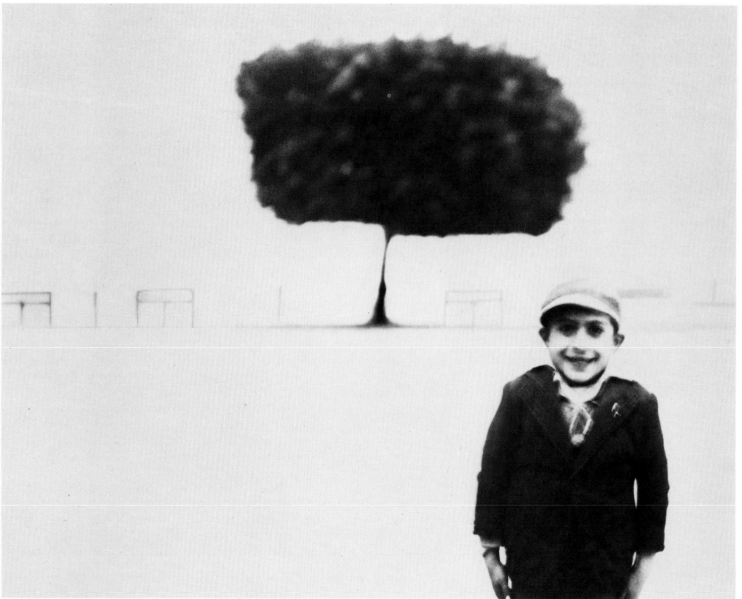

RICHARD AVEDON: *Sicily*, 1947

In the picture of a Sicilian boy (left) a feeling of strangeness and foreboding is purposely conveyed by what appears to be a breakdown in the photographic process. The makings of a happy, rather ordinary snapshot are here —an eagerly posing boy, a tree, a fence —but the result is a grainy, overexposed image so blasted by light that all material things seem on the verge of being dissolved. The viewer can only conclude that something is wrong —but does not know what.

Everyday reality is again altered in this surrealistic scene taken near a new shopping center in Paris. Gigantic shadows stretch across the ground, pointing toward a wall on which, it appears, a man is walking. Curiously, the man's shadow and the shadows on the ground fall in opposite directions. It is as if the man walking on the wall lived in another world where the laws of gravity do not operate and another sun shines. In fact the walking man is painted on the wall —a mural decorating the entrance to the shopping center —but at first glance he looks more real than the real human shadows on the ground.

FRANCO FONTANA: *Presences*, 1979

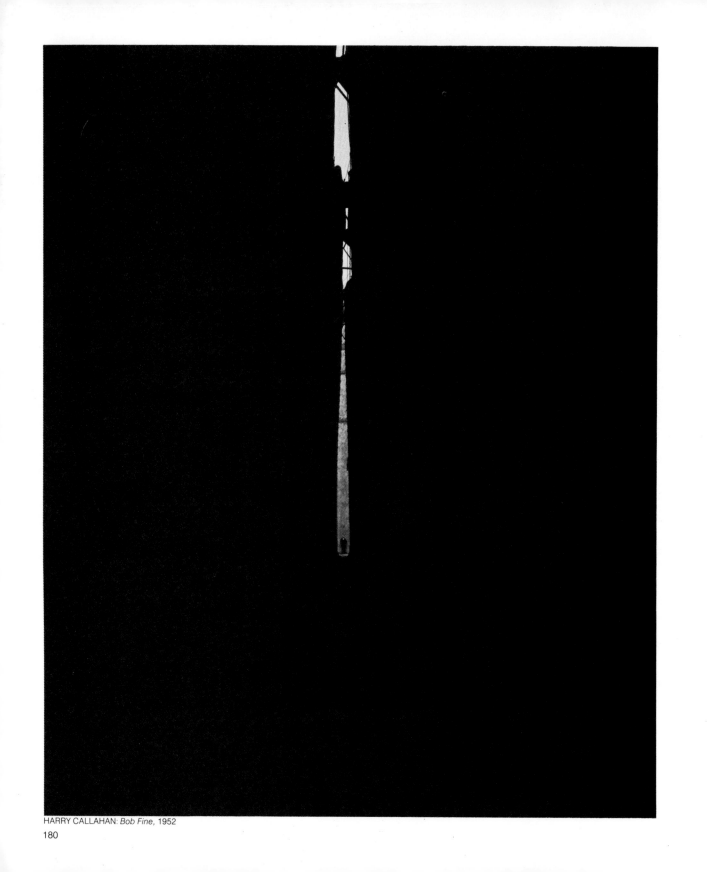

HARRY CALLAHAN: *Bob Fine*, 1952

180

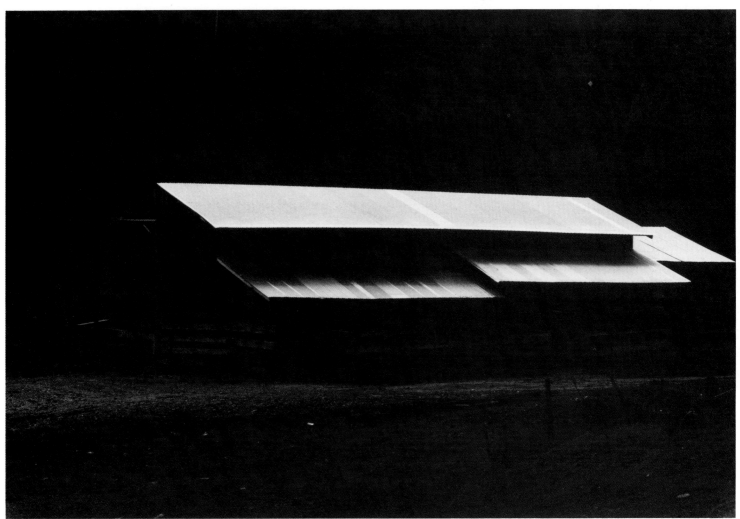

GARY L. PRATHER: *Stable on Route 128,* 1966

◄ *The picture opposite violates familiar proportions with a vengeance, reducing a man to a mere speck, dwarfed by two looming grain elevators. But by turning the elevators into areas of blackness, the photographer has ingeniously made the presence of the man apparent, even as he cuts him down to size. There is only one path for the viewer's attention to follow—right down the shaft of light to the tiny figure at the bottom.*

The photographer saw only wonderfully clean-lined shapes when he came upon a roadside stable one rainy day while driving north of San Francisco. The glistening roofs appeared to float. He stopped and waited for the rain to let up. Then, shooting in sunlight and exposing to darken everything but the roof, he changed the stable into a structure of angles and planes that seems perfectly self-sufficient as it hovers in a void.

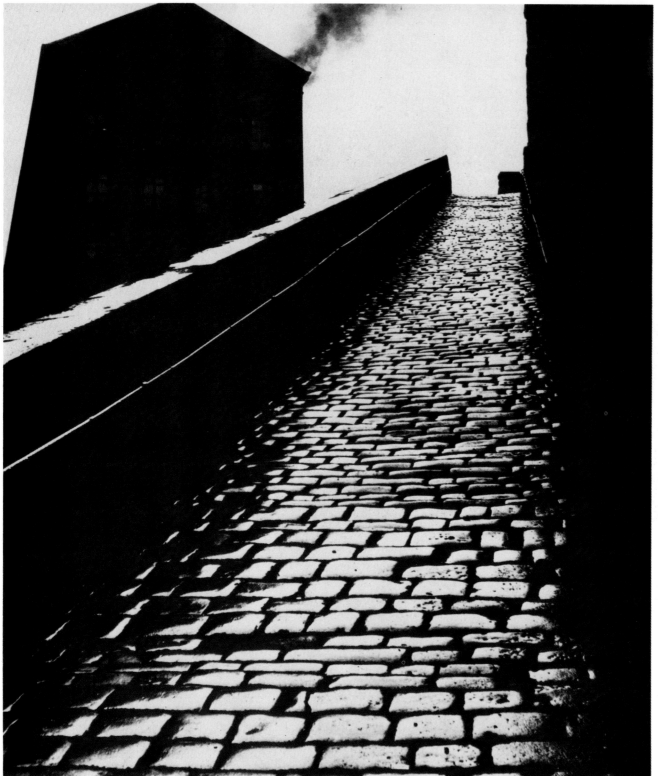

BILL BRANDT: *Halifax,* 1937
182

◀ *Halifax, in the coal-producing Yorkshire region of northern England, looks as glossy and black as anthracite in the picture opposite. High-contrast printing turned the factory into an irregular shape without depth, and emphasized the pattern of the brick roadway. The road leads the eye back and up into the picture, then appears to pitch off in space, as if chopped by some sudden ax stroke.*

Artistry admits no limits of age. Jacques Henri Lartigue took the happy photograph at right in 1904, when he was eight years old. Although the balloon has just been tossed up by his nanny, it could be rising, falling or hovering. The picture is so neatly balanced that the latter seems most likely to be true, imparting a sense of airy lightness entirely appropriate to the mood. Lartigue did indeed shoot at the moment the balloon reached the peak of its flight, for only then would it be motionless — so still it would not blur in the long exposure his slow film required.

JACQUES HENRI LARTIGUE: *Nanny Dudu and Balloon,* 1904

OTTO STEINERT: *Paris Pedestrian,* 1951

A pattern of radiating lines and concentric rings is given highest priority in the picture above. It is first stated strongly by the protective grid at the base of the tree, then echoed weakly by the bricks of the street. The passing pedestrian might have figured more prominently in the picture if he were completely visible, but he is blurred, except for one foot, by a ¼-second exposure—a footnote that makes it clear he will soon be gone from the scene but the arresting pattern will remain.

A dazzling study of form is presented in the ▶ picture opposite, which establishes a complementary relationship between a tree and the surrounding valley. The cylindrical form of the trunk (just enough of the leafy top is shown to indicate the tree's identity and scale) and the ring form of the valley are concentric, conforming to each other. Seen together, they suggest the energy latent in a carousel, for the valley appears ready to spin around the axis of the trunk.

LENNART OLSON: *Ste. Agnès, Provence, France,* 1955

Lace pinned to the edge of a coastal bluff makes a visual pun, simulating the filigree of frothy surf several hundred feet below. The lace, a beach stroller barely visible at center and bands of surf draw the viewer's eye horizontally across the frame.

JOHN PFAHL: *Wave, Lave, Lace, Pescadero Beach, California,* 1978

Another beach stroller—French philosopher
Jean-Paul Sartre—appears in this picture, also
dominated by horizontal lines. The forward thrust of
his body and shadow is emphasized by the inclusion
of only the parallel shadow of his wife behind him.

ANTANAS SUTKUS: *Jean-Paul Sartre,* 1965

◀ *To create this design of repeated shapes, the photographer looked down from an airport mezzanine on a group of nuns and filled his frame with the contrasting elements of their habits — severe black robes and white, flower-like coifs.*

Shapes repeat themselves at right to charge the picture with the emotion felt by the photographer. The men are recruits training in Biafra during the 1968 revolt against Nigeria. By using a long lens to crowd and flatten their forms, the photographer has deliberately robbed them of individuality and portrays them as a mass of anonymous, interchangeable men huddled together for warfare.

DAVID MOORE: *Sisters of Charity, Washington, D.C.,* 1956

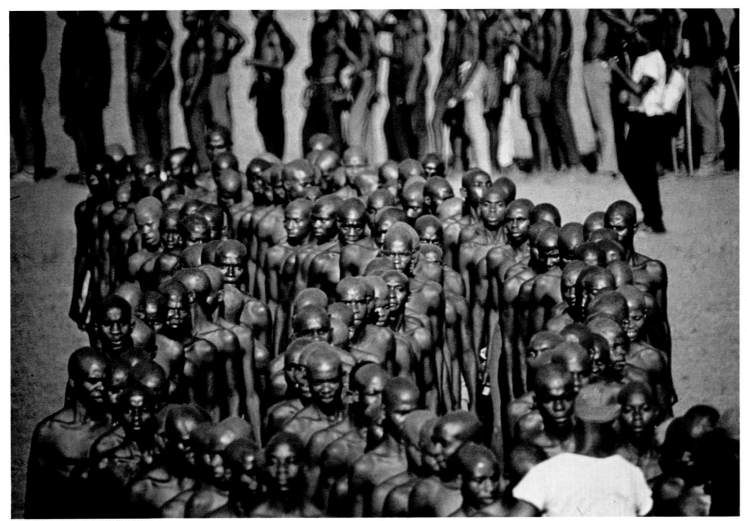

ROMANO CAGNONI: *Soldiers*, 1968

At left, André Kertész confronts the viewer with a paradox: a still life with a highly expressive gesture implied. The tulip droops like a ballet dancer bidding a farewell to an applauding audience. Although the metaphoric gesture does suggest fatigue, it is extremely graceful—an impression reinforced by a rhythmic organization. Four stages of decline are evident: the upright leaf at the top of the vase; a second, horizontal leaf; a third, drooping one; and finally the down-pointing stem, which completes the rhythmic flow.

An indomitable personality is captured in this ▶ portrait of Isak Dinesen (opposite)—the Danish baroness whose long career ranged from farming and nursing in Africa to writing world-famous Gothic tales. Proportion conveys the photographer's response: By aiming upward, making the head seem imperiously perched atop the great bundle of a wolfskin coat, Richard Avedon suggests Miss Dinesen's outsized spirit.

ANDRÉ KERTÉSZ: *Melancholy Tulip*, 1939

RICHARD AVEDON: *Isak Dinesen*, 1958

Powerful emotions of childhood freedom and loneliness are evoked by a picture that seeks to generate the deep, disturbing feelings of a dream by a representational approach that seems somehow wrong. True: this is a composite, made by pasting several prints together. The swinging boy and the grass in the foreground were printed from one negative made at a park. The houses were printed from another negative made in a provincial town. Looking closely, the viewer realizes that the houses on both sides of the picture are the same image; the negative was printed once, then flopped and printed again. The right side has been made dark in printing to simulate shadows and conceal the visual trick.

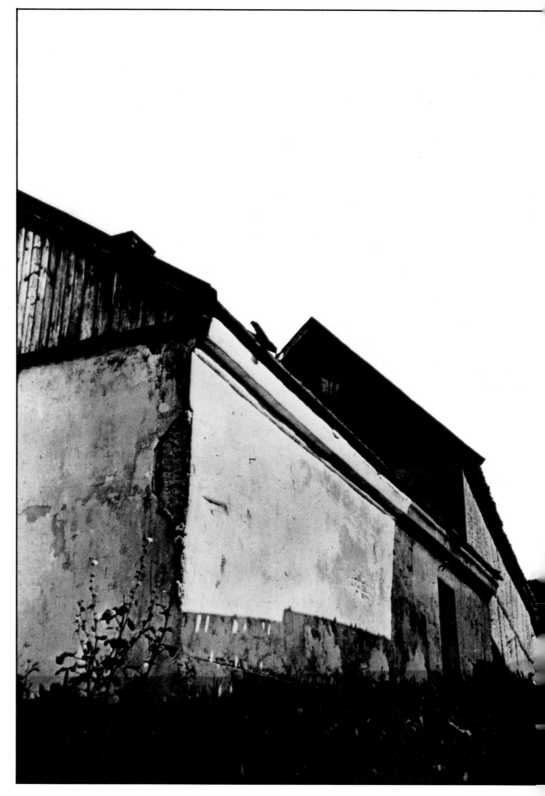

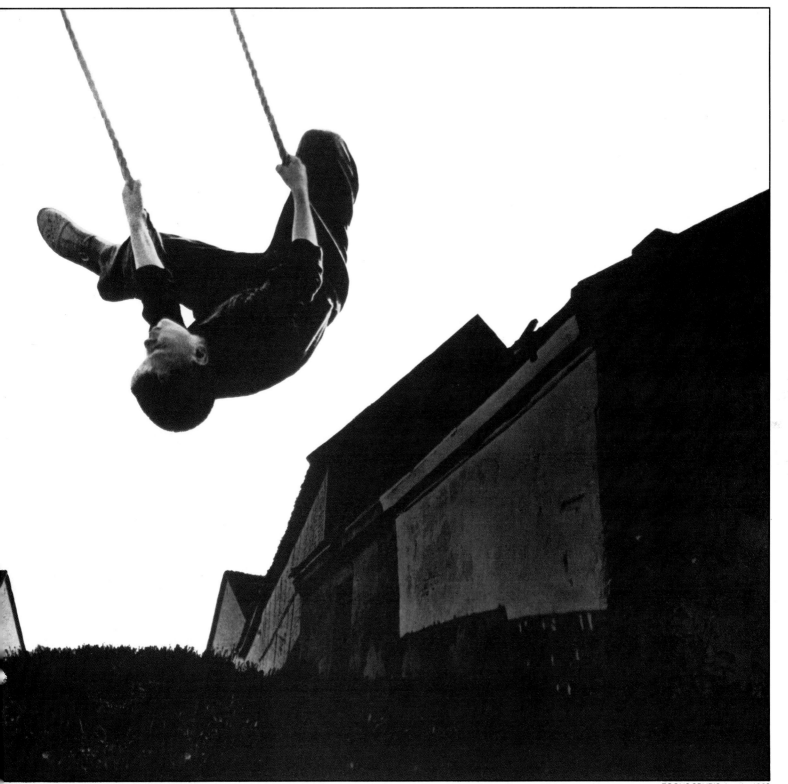

EGONS SPURIS: *Inertia*, 1968

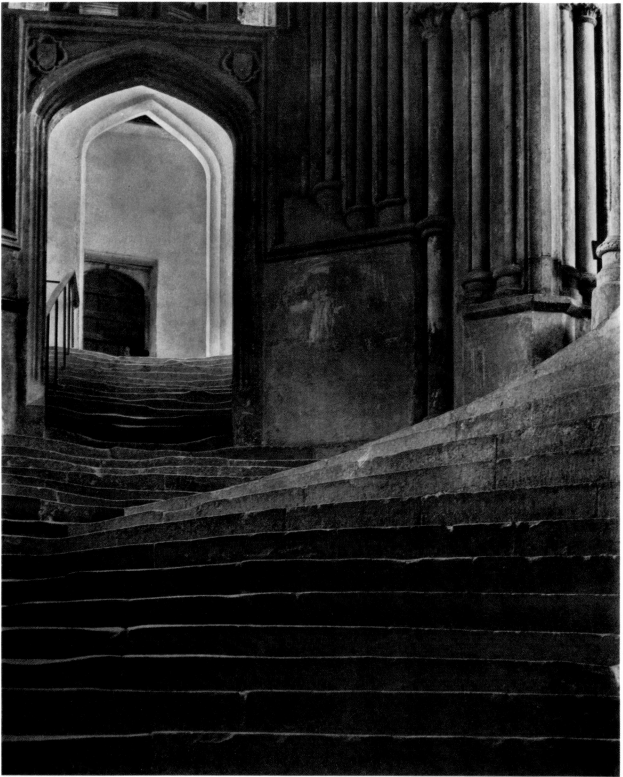

FREDERICK EVANS: *Sea of Steps*, 1903

◀ *Carefully orchestrated rhythms give the picture of a stairway in Wells Cathedral, England (left), the surging flow of an ocean swell. Almost everything in the scene displays gradual modulation: The receding steps grow smaller and narrower; the vertical pattern of the columns at top narrows as it nears the archway; and the archway turns out to be many smaller arches.*

Nuns restrain a melancholic woman in a play about the inmates of a mental institution, the undulating shapes of their headdresses echoing the contours formed by the woman's arms and back. The nuns seem to shelter and protect her at the same time that they confine her.

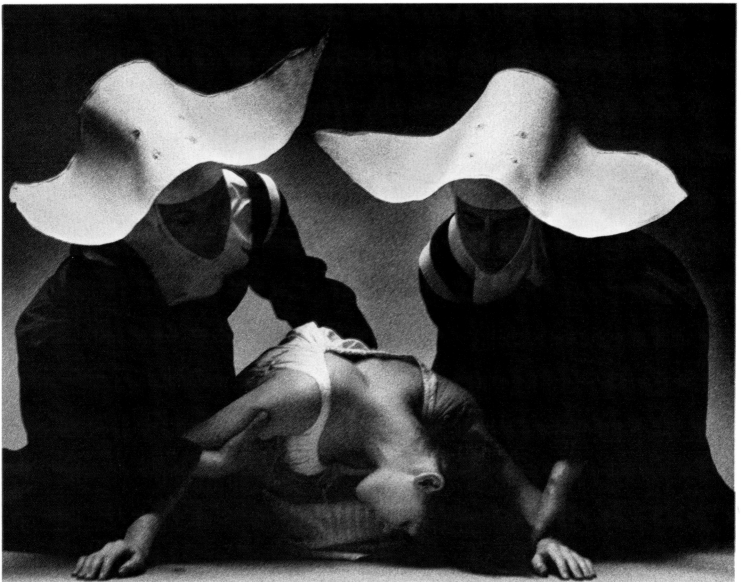

MAX WALDMAN: *Scene from the play, Marat/Sade,* 1966

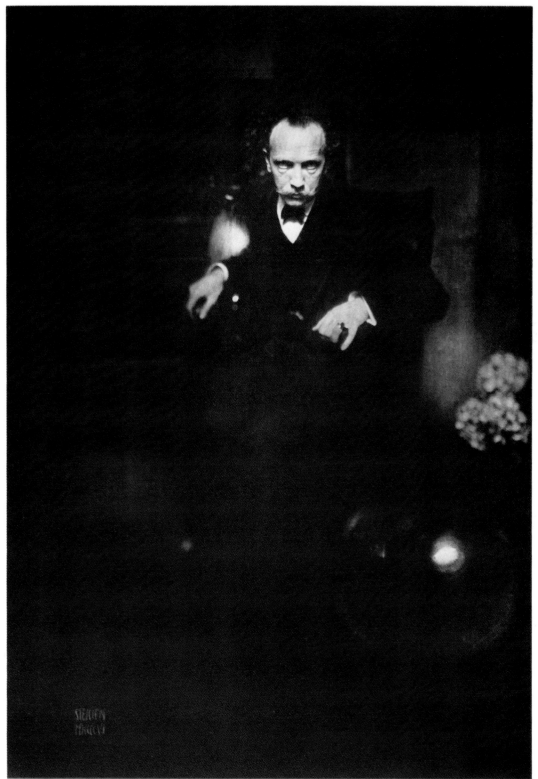

The photographer's assessment of the character of his subject is instantly apparent in this portrait, which catches the German composer Richard Strauss leaning forward with a fixed and belligerent stare, like a lion ready to spring. The almost unbroken expanse of blackness surrounding Strauss adds to the impression of tremendous force, barely held in check.

EDWARD STEICHEN: *Richard Strauss,* 1906

Bent with fatigue and despair, an unemployed British miner plods homeward with a scavenged bag of coal. The photographer's vantage point and instant of exposure were chosen to frame the man against the light-toned path so that his hunched posture would be clearly outlined. The theme of misery is reiterated by the landscape —dark, treeless and overhung by a sooty sky.

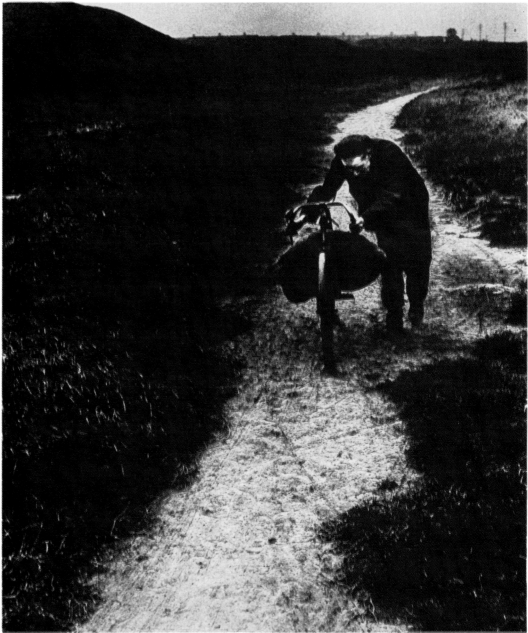

BILL BRANDT: *Coal Searcher Going Home to Jarrow*, 1937

In this street scene, an unearthly luminosity surrounds otherwise ordinary pedestrians who cast shadows in two directions. Actually, the strong second light is also sunlight, reflected from the glass façade of a building that is outside the range of the camera. But in the photograph, the second light source is unexplained and mysterious, suggesting a light from another world.

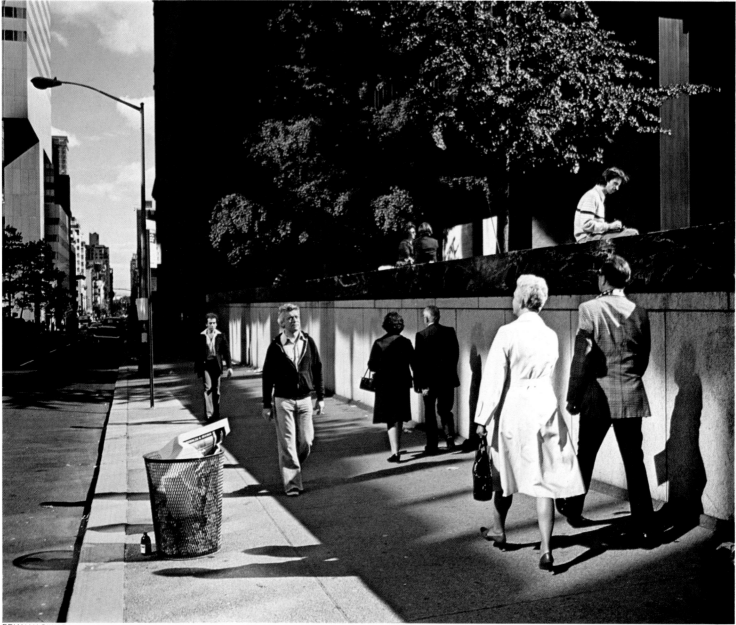

BRIAN HAGIWARA: *53rd Street, New York City,* 1978

An aspen grove in Colorado was shot in light so diffused it has no apparent source, eliminating shadows that would have vied with the vertical pattern formed by the repeated trunks. An aperture stopped down to f/45 gave maximum depth of field. As a result, the trees appear to recede endlessly; the viewer is invited to step into the picture frame and to walk deep into the grove.

GEORGE TICE: *Aspen Grove in Colorado,* 1969

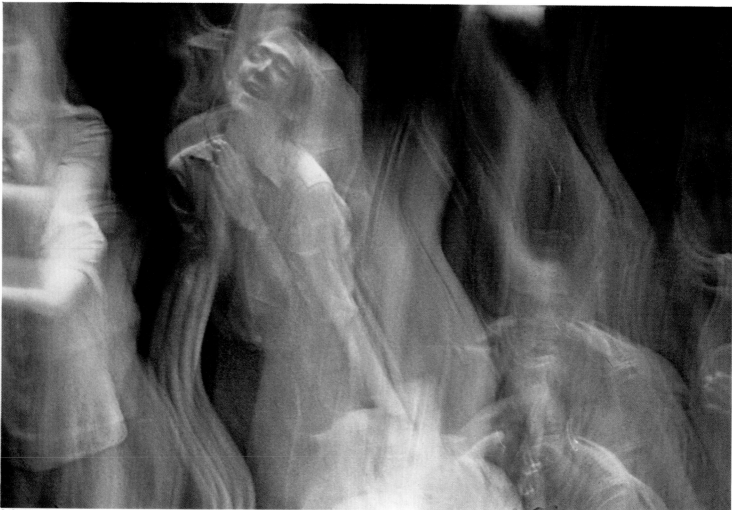

GJON MILI: *Scene from The Me Nobody Knows,* 1978

To imbue a scene from a Broadway musical with movement, a slow shutter speed caused the image of each actor to blur; moving the camera during exposure—panning—added to the blur and created fluid streaks between figures. What the picture loses in sharpness, it more than gains in force.

ANTON GIULIO BRAGAGLIA: *Greeting,* 1911

*The principal visual ingredient of the picture
above is a shape that the camera could see much
better than the eye — the shape of a gesture,
captured in a time exposure as a man smiled,
bowed and made a sweeping motion of salutation.
The photographer, Anton Giulio Bragaglia,
originated a photographic philosophy he called
"Fotodynamics" (an offshoot of Futurist art),
whose esthetic purpose he summed up by saying:
"We consider life as pure movement."*

The photographer deliberately avoided catching a visual crest of interest in the picture at left, choosing to expose instead at what seems to be a random instant, with the old man partly hidden under the boardinghouse stairs. Such depiction of "random" time conveys an ordinary, uncontrived sort of perception. And by leaving out something expected—the head of the subject, in this case—it jolts the viewer awake, just as sudden silence can disturb a city dweller used to constant noise.

In a portrait of the novelist Aldous Huxley, the ▶ subject is again half-hidden—but not, as at left, in an effort to convey casual perception. Here, the cleverness and pithy statement are paramount. Huxley, a scathing satirist, is shown spying on the world with one bespectacled eye—and quite ready to dive back into hiding. The photographer placed a light behind Huxley so his shape could be seen through the thin curtain, suggesting that he will be there watching and listening even when the curtain is closed.

ROBERT FRANK: *Rooming House in Los Angeles,* 1955

CECIL BEATON: *Aldous Huxley*, 1935

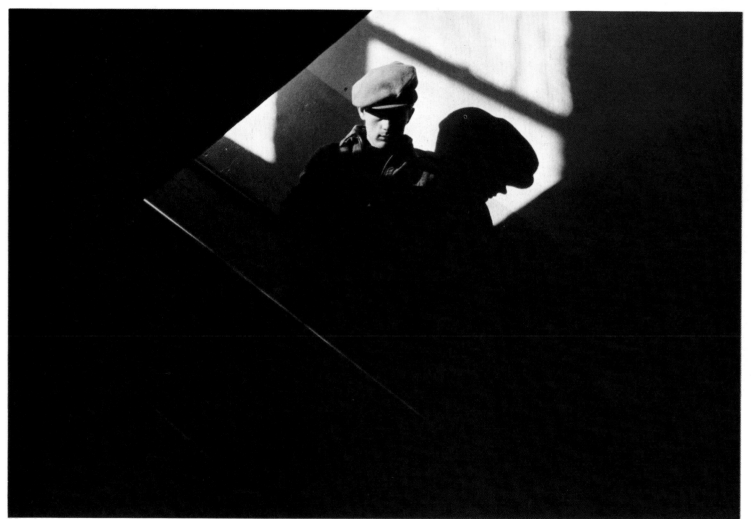

DENNIS STOCK: *James Dean in Light and Shadow*, 1955

A portrait of the actor James Dean, made in the year of his death, is brilliantly composed to suggest a personality full of contradictions —boyish and manly, polite and wild, sensitive and tough. Although Dean is dressed in rough clothes and the setting seems to be a gloomy alleyway, the organization is formal and almost symmetrical, with the subject placed in the center of a diamond-shaped frame of light and shadow. Two other dualities: His face is halved into light and darkness; and his head is shown both straight on and in profile—the shadow cast on the wall.

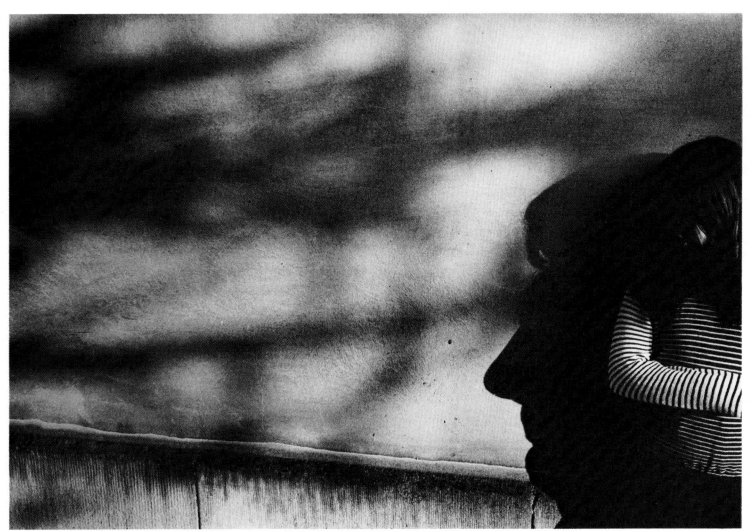

PAUL HILL: *Girl in Striped Shirt, Matlock Bath, England,* 1976

A shadow adds unexplained implications in this informal portrait of a young girl standing against a wall. The photographer was shooting shadows cast on the wall by nearby trees when the girl, the photographer's daughter, turned her head so that her body cast a shadow resembling an oversized man's profile onto the wall. There is no man visible in the picture, and the gigantic shadow suggests the presence of an intruder.

*A seemingly cursory glimpse of a London street
generates a powerful sense of isolation. The
photographer has established three more-or-less-
equal points of interest with no real connection
between them. One is the girl inexplicably running
down the sidewalk; the eye is drawn toward her by
the strongly stated perspective of converging lines.
A second focus of interest is the trash collector,
brought to the viewer's attention by being framed in
the rear window of the hearse. And the third is the
hearse itself, which disturbs the viewer by its
implication of death—though it is almost callously
ignored by the two living people in the picture.*

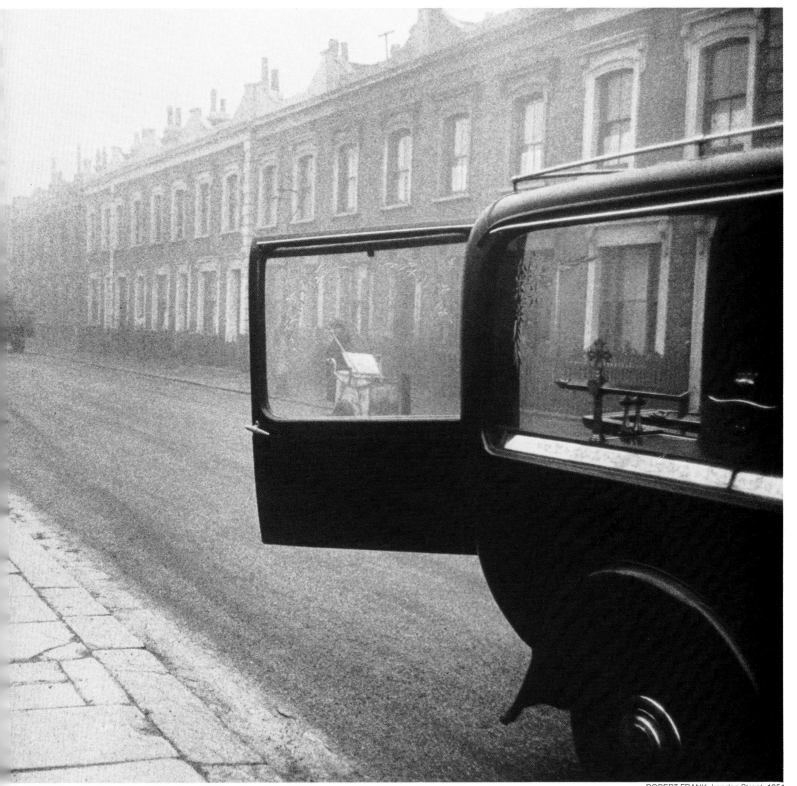

ROBERT FRANK: *London Street,* 1951

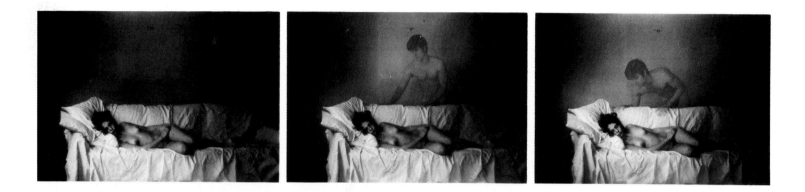

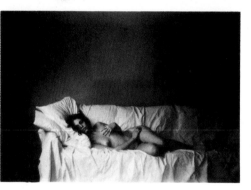

DUANE MICHALS: *The Young Girl's Dream,* 1969

Photographs made in sequence, almost as if they were stills from a motion picture, suggest realms of fantasy and the supernatural in five frames depicting a sleeping girl's erotic dream. The ghostly image of the dreamed lover was achieved by a simple technique, double exposure. The man appeared during only part of the exposure in each picture where he is present, and not all his features had time to register on the film.

In another type of sequence, the same object is ▶ photograhed from three different distances and three different points of view; the combination is explained—or made more mysterious—by the enigmatic legend written below the sequence. "Is this how youth and radiance leave us?" may refer to poetic comparisons between life and a glass of wine, though the photographer has given the sentiment a comic twist: The cup is clearly common plastic and probably filled with soda pop.

Is this how youth & radiance leave us?

BART PARKER: *Untitled*, 1979

DIANE ARBUS: *Midget Friends,* 1963

The woman midget at center rests her hand on the man's shoulder, leaning confidently toward him, while the woman at right inclines toward them. By this artful arrangement of forms, the photographer clearly established her response to the subjects. The viewer senses at once that there is a relationship between the people (and they are, indeed, good friends — all belonging to a troupe of midgets who first came to America in 1923 with a circus). The sense of warmth indicated by the pose overrides any inference of freakishness; these are human beings who happen to be small.

Entitled Madonna, the picture of a mother and child at right gains an icon-like quality from the rigid stances and silhouetted profiles. There is even a halo of sorts around the woman's head, formed by the curved top of the window. The photographer has highlighted and framed the picture — and accentuated the rigid pose — simply by bending some of the Venetian blinds.

RALPH EUGENE MEATYARD: *Madonna*, 1969

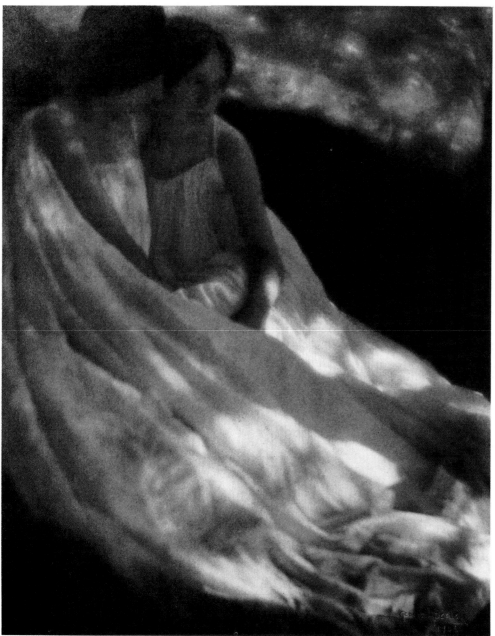

Soft focus and subtle gradation of tone aid in
the expression of a classical subject—two women
photographed to suggest they are watching
the burning of Rome. In the pictorialist tradition
of simulating 19th Century painting, the
photographer's response to the subject is highly
romantic—and is expressed in the languorous
pose of the women, the almost liquid flow of their
gowns, and the lambent light (presumably
from flaming houses) playing over the scene.

At the opposite pole from romance, the picture of ▶
Welsh coal miners is all grit, grimness and
hostility. The grouping of the men against the
background of their row houses seems to belong
to a traditional sort of timeless portraiture. Yet
the restlessness of their mood, indicated by the
defiant cigarette and the averted eyes, marks
the miners as prisoners of their time and place.

GEORGE H. SEELEY: *The Burning of Rome,* 1906

W. EUGENE SMITH: *Welsh Miners*, 1960

ZDENĚK VOZENÍLEK: *Winter in Prague,* 1961

The photographer's affectionate response to the city of Prague suffuses his happy sledding scene. In an expansive photographic embrace, he encompasses a panorama of architecture and dozens of human episodes. Except for the contemporary dress, this could almost be the peaceful Prague of good King Wenceslaus, who reigned here in the 13th Century.

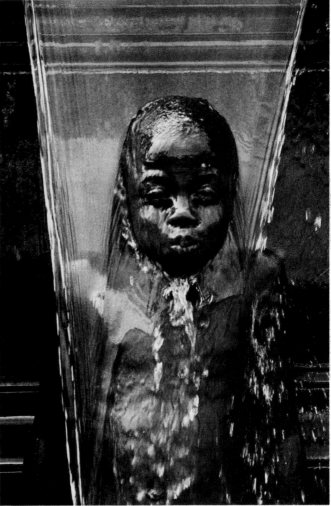

GEORGE KRAUSE: *Fountainhead*, 1969

A vision of summertime delight is offered by this picture of a boy cooling off under the overflow of an outdoor fountain in Philadelphia. But the texture of the water has been used to imply wider meanings. The cascading sheet of water, coating the boy's face with its own sheen, creates the illusion of a bas-relief head carved on a wall. This photograph becomes more than a simple depiction of boyish play; it proclaims the presence of art in life, as well as life in art.

SCOTT MACLAY: *Woman's Arm and Chair*, 1979

*Normally, chopping off parts of a subject's body is
something to avoid, but here unusual framing
creates a balanced design. By positioning the edges
of the picture as he has, the photographer gave
the disembodied arm just the same weight — and
space — as other elements in the picture. It was
this framing decision, so powerfully affecting
balance, that leads to the sense of suspended
animation characterizing the photograph.*

Bibliography

Visual Elements and Principles of Design
*Anderson, Donald M., *Elements of Design*. Holt, Rinehart and Winston, 1961.
†Arnheim, Rudolf, *Art and Visual Perception*. University of California Press, 1967.
†Birren, Faber, *Color Perception in Art*. Van Nostrand Reinhold Company, 1976.
Croy, O. R., *Design by Photography*. Focal Press, 1963.
Feldman, Edmund Burke, *Art as Image and Idea*. Prentice-Hall, 1967.
Garrett, Lillian, *Visual Design: A Problem-Solving Approach*. Van Nostrand Reinhold, 1967.
Gibson, Ralph, ed., *Contact: Theory*. Lustrum Press, 1980.
Kepes, Gyorgy:
 —ed., *Education of Vision*. George Braziller, 1965.
 Language of Vision. Paul Theobald, 1967.
 —ed., *Module, Proportion, Symmetry, Rhythm*. George Braziller, 1966.
†Lyons, Nathan, *Photographers on Photography*. Prentice-Hall, 1966.
Stroebel, Leslie, Hollis Todd, and Richard Zakia, *Visual Concepts for Photographers*. Focal Press, 1980.
*Taylor, John F. A., *Design and Expression in the Visual Arts*. Dover, 1964.
Weismann, Donald L., *The Visual Arts as Human Experience*. Prentice-Hall, 1970.

Photography and Time
Cartier-Bresson, Henri:
 The Decisive Moment. Simon and Schuster, 1952.
 †*Photographs by Cartier-Bresson*. Grossman, 1963.
Frank, Robert, *The Americans*. Grossman, 1969.
Newhall, Beaumont, *The History of Photography from 1839 to the Present Day*. The Museum of Modern Art, Doubleday, 1964.

Challenging the Traditions
Bennett, Steichen, Metzker: The Wisconsin Heritage in Photography. Milwaukee Art Center, 1970.
Contemporary Photographs. UCLA Art Galleries, 1968.
Desmarais, Charles, ed., *The Portrait Extended*. Museum of Contemporary Art, Chicago, 1980.
Evans, Ralph M., *Eye, Film and Camera in Color Photography*. John Wiley and Sons, 1959.
Goodman, Nelson, *Languages of Art*. Bobbs-Merrill, 1968.
Into the 70's: Photographic Images by Sixteen Artists/Photographers. Akron Art Institute, 1970.
Jerry N. Uelsmann. Philadelphia Museum of Art, Aperture, 1970.
Lyons, Nathan, ed.:
 Aaron Siskind: Photographer. George Eastman House, 1965.
 The Persistence of Vision. Horizon Press, George Eastman House, 1967.
 Vision and Expression. Horizon Press, George Eastman House, 1969.
†McCray, Marilyn, *Electroworks*. International Museum of Photography, George Eastman House, 1979.
*Ward, John L., *The Criticism of Photography as Art: The Photographs of Jerry Uelsmann*. University of Florida Press, 1970.

The Principles at Work
Ballo, Guido, *The Critical Eye: A New Approach to Art Appreciation*. G. P. Putnam's Sons, 1969.
Gernsheim, Helmut, *Creative Photography, Aesthetic Trends 1839-1960*. Faber and Faber, 1962.
Hedgecoe, John, *The Art of Color Photography*. Simon and Schuster, 1978.
Hook, Sidney, ed., *Art and Philosophy, A Symposium*. New York University Press, 1966.
Steichen, Edward, *A Life in Photography*. Doubleday, 1963.
†Szarkowski, John, *The Photographer's Eye*. The Museum of Modern Art, Doubleday, 1966.
Vivas, Eliseo, and Murray Krieger, *The Problems of Aesthetics*. Rinehart, 1957.

*Available only in paperback.
†Also available in paperback.

Acknowledgments

The index for this book was prepared by Karla J. Knight. For help given in the preparation of this book, the editors are particularly indebted to Martus Granirer, New City, New York, who served as a special consultant. The editors would also like to express their thanks to the following: David Attie, New York City; Wynn Bullock, Monterey, California; Peter Bunnell, Curator, Department of Photography, The Museum of Modern Art, New York City; Wolf von dem Bussche, New York City; Walter Clark, Rochester, New York; Raymond Baxter Dowden, New York City; Marcia Kay Keegan, New York City; Harvey Lloyd, New York City; Marilyn McCray, Rochester, New York; Charles Mikolaycak, New York City; Allan Porter, Editor, Camera, Lucerne, Switzerland; Walter Rosenblum, Professor, Department of Art, Brooklyn College, New York; Joel Snyder, Chicago; Harald Sund, Seattle.

Picture Credits
Credits from left to right are separated by semicolons, from top to bottom by dashes.

COVER: Ken Kay; Jack Schrier

Chapter 1: 11: Ralph Weiss. 14: Jesse Birnbaum. 15: Tony Ray-Jones. 23-31: Sebastian Milito. 32: Paul Caponigro. 33: Bill Brandt from Rapho Guillumette. 34: George A. Tice. 35: © William Garnett. 36: Stanley R. Smith. 37: Elisabetta Catamo, Rome. 38: Aaron Siskind. 39: © Barbara Morgan. 40: Irving Penn, courtesy *Vogue,* © 1968 Condé Nast Publications Inc. 41: © John Batho, Paris. 42: Giséle Freund, Paris. 43: Lisl Dennis/The Image Bank. 44: Gail Rubin. 45: Ernst Haas. 46: © Eberhard Grames, Düsseldorf. 47: Reinhart Wolf, Hamburg. 48, 49: Kazuyoshi Nomachi, Tokyo. 50: Minor White. 51: Paul Caponigro. 52: Erwin Fieger, Arezzo. 53: © Harry Gruyaert, Paris. 54: Minor White. 55: Paul Strand, copied by Paulus Leeser. 56: © Robert Perron.

Chapter 2: 59: Wolf von dem Bussche. 64-71: Wolf von dem Bussche.

Chapter 3: 77: Harold Zipkowitz. 81: Marcia Kay Keegan. 82: Richard Noble. 84, 85: Dean Brown. 86, 87: Pete Turner. 88: Richard A. Steinberg. 90, 91: Duane Michals. 93: David Plowden. 95: Sheila Metzner. 97: Grant Mudford. 98: Robert Doisneau, Paris. 101: Luigi Ghirri, Modena. 102, 103: Leonard Freed from Magnum. 105: Lou Stoumen. 106, 107: Starr Ockenga. 108, 109: Peter Magubane. 110: © Alex Webb from Magnum. 112: Diane Arbus.

Chapter 4: 115: Paul Strand. 118, 119: William Gedney. 120: August Sander. 121: Roy DeCarava. 122: Martine Franck from Magnum. 123: Bruce Davidson from Magnum. 124, 125: Thomas Brown; Joel Sternfeld. 127: Henri Cartier-Bresson from Magnum. 128: Michael Semak. 129: Henri Cartier-Bresson from Magnum. 130: © André Kertész. 131: Mario Giacomelli. 132, 133: Mary Ellen Mark; Josef Koudelka from Magnum, Paris. 134, 135: Ian Berry from Magnum; Jack Schrier. 137: Robert Frank. 138, 139: Garry Winogrand. 140: Lee Friedlander. 141: Mark Cohen. 142: Robert Frank. 143: Antonin Kratochvil. 144: Nazif Topcuoglu.

Chapter 5: 147: George Curtis Blakely II. 148: Aaron Siskind. 151: Kay K. Metzker. 152: Ken Josephson. 153: Evon Streetman. 154, 155: Reed Estabrook. 156: Tetsu Okuhara, courtesy National Gallery of Australia, Melbourne. 157: Patrick Nagatani, courtesy Jean Gardner, *Picture Magazine*. 158: Esther Parada. 159: Paul Berger. 161: David Haxton, courtesy Sonnabend Gallery. 162: Jerry McMillan. 163: Robert Cumming, courtesy Paradox Editions Limited. 164: Tom Drahos, Paris. 165: Sandy Skoglund, courtesy Castelli Graphics, New York. 166, 167: Esta Nesbitt, courtesy Saul Nesbitt. 168: Judith Christensen. 169: Sonia Landy Sheridan, courtesy of International Museum of Photography at George Eastman House. 170: Peter Astrom, courtesy of International Museum of Photography at George Eastman House. 171: Joan Lyons. 172:

Suda House, copied by Fil Hunter.

Chapter 6: 175: André Kertész. 178: Richard Avedon. 179: Franco Fontana, Modena. 180: Harry Callahan. 181: Gary Prather. 182: Bill Brandt from Rapho Guillumette, courtesy The Museum of Modern Art, New York. 183: Jacques-Henri Lartigue from Rapho Guillumette. 184: Otto Steinert, courtesy The Museum of Modern Art, New York. 185: © Lennart Olson/Tio. 186: John Pfahl, courtesy of the Robert Friedus Gallery and the Visual Studies Workshop Gallery. 187: Antanas Sutkus, Vilnius, Lithuania. 188: David Moore, Australia. 189: Romano Cagnoni, London. 190: André Kertész. 191: Richard Avedon. 192, 193: Egons Spuris. 194: Frederick Evans, courtesy Library of Congress. 195: © Max Waldman, 1966. 196: Edward Steichen, courtesy The Museum of Modern Art, New York. Bill Brandt from Rapho Guillumette, courtesy The Museum of Modern Art, New York. 198: Brian Hagiwara. 199: George A. Tice. 200: Gjon Mili. 201: Anton Giulio Bragaglia, courtesy Archivo A. V. Bragaglia of Centro Studi Bragaglia, Rome. 202: Robert Frank. 203: Cecil Beaton. 204: Dennis Stock from Magnum. 205: © Paul Hill, Derbyshire. 206, 207: Robert Frank. 208: Duane Michals. 209: Bart Parker. 210: Diane Arbus. 211: © Ralph Eugene Meatyard. 212: George H. Seeley, courtesy The Metropolitan Museum of Art, New York, gift of Alfred Stieglitz, copied by Anthony Donna. 213: © W. Eugene Smith. 214, 215: © Zdeněk Vozenilek; George Krause. 216: Scott MacLeay, Paris.

Text Credit

Chapter 1: 12, 16, 17, 18, 19, 20, 21—Marginal quotes from *Photographers on Photography*, edited by Nathan Lyons, copyright 1966 by Prentice-Hall, Inc., Englewood Cliffs, New Jersey, in collaboration with George Eastman House, Rochester, New York.

Index
Numerals in italics indicate a photograph, painting or drawing.

Printed in U.S.A.